HOW TO DRAW
MANGA
Computones
Vol. 2

D1210923

HOW TO DRAW MANGA:
Computones Vol. 2
Humans
by Kento Shimazaki

This book was first designed and published in 2005 by Graphic-sha Publishing Co., Ltd.
Sansou Kudan Bldg., 4th Floor, 1-14-17 Kudan-kita, Chiyoda-ku, Tokyo 102-0073, Japan.

Original cover design and text page layout: Shinichi Ishioka
English translation management: Língua fránca, Inc. (an3y-skmt@asahi-net.or.jp)
Planning editor: Masahiko Satake (Graphic-sha Publishing Co., Ltd.)
Publishing coordinator: Michiko Yasu (Graphic-sha Publishing Co., Ltd.)
Project management: Kumiko Sakamoto (Graphic-sha Publishing Co., Ltd.)

First printing: July 2005

Collaborating Artists:	Chizuko Beppu Tami Makoto Iwasaki
Cover Illustrator:	Kouji Nakakita
Color Coordinator:	Junya Hasegawa
Special thanks to:	Yutaka Murakami (M Create Co., Ltd.)

ISBN: 4-7661-1523-6
Printed and bound in China by Everbest Printing Co., Ltd.

Table of Contents

Chapter 3: Manual...79

On the Techniques and Images Included and Introduced in this Book

Aside from a few exceptions, all of the original pieces in this book were created at a 600 dpi resolution in grayscale. Readers who will use the included CD-ROM and do their tone work on a computer are encouraged to do so on a machine that meets the indicated OS, CPU, memory, and hard disk requirements.

How to Use the Included CD-ROM

In order to use the included tone patterns CD-ROM, you must have at least one of the following software packages installed: Adobe Photoshop 5.0/5.5/6.0/7.0/CS or Adobe Photoshop LE 5.0; Adobe Photoshop Elements 1.0/2.0; Jasc Paint Shop Pro 7.0/8.0

Please use the CD-ROM after you have installed one of the above.

Use Tones for an Expressive Power Up!!

Normally, *manga* are done entirely in black and white, but tones are one way to add charm to a *manga* character. By using tones to add color or shading to a character's skin, it is possible to add greater depth and dimension, and make character appear real.

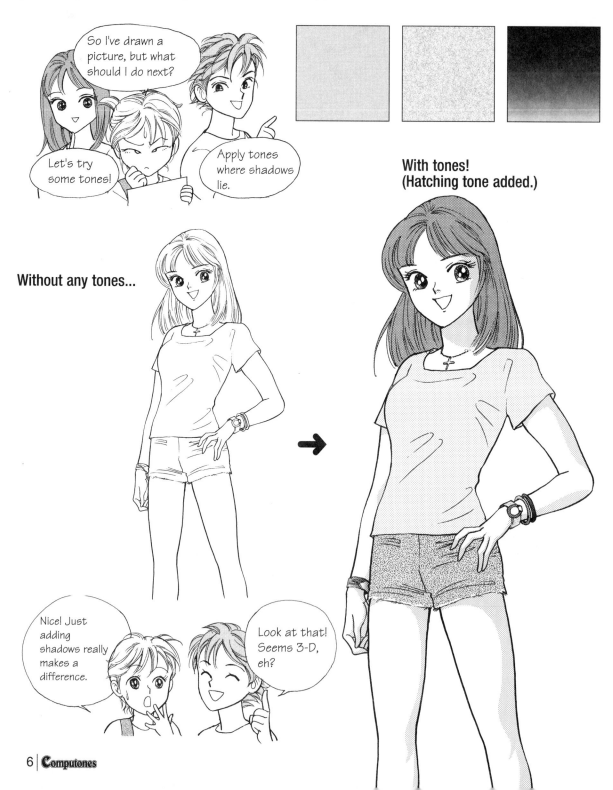

So I've drawn a picture, but what should I do next?

Let's try some tones!

Apply tones where shadows lie.

With tones!
(Hatching tone added.)

Without any tones...

Nice! Just adding shadows really makes a difference.

Look at that! Seems 3-D, eh?

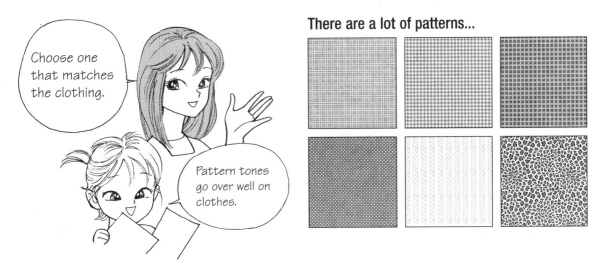

There are a lot of patterns...

Let's try dressing her up with a pattern tone.

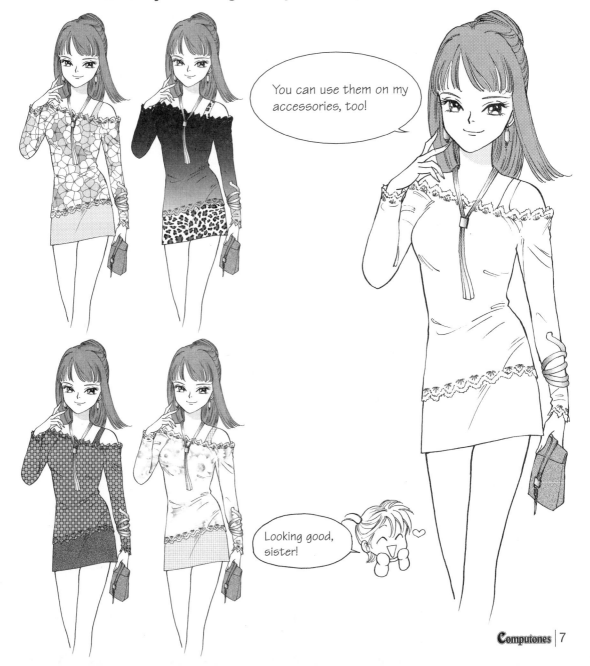

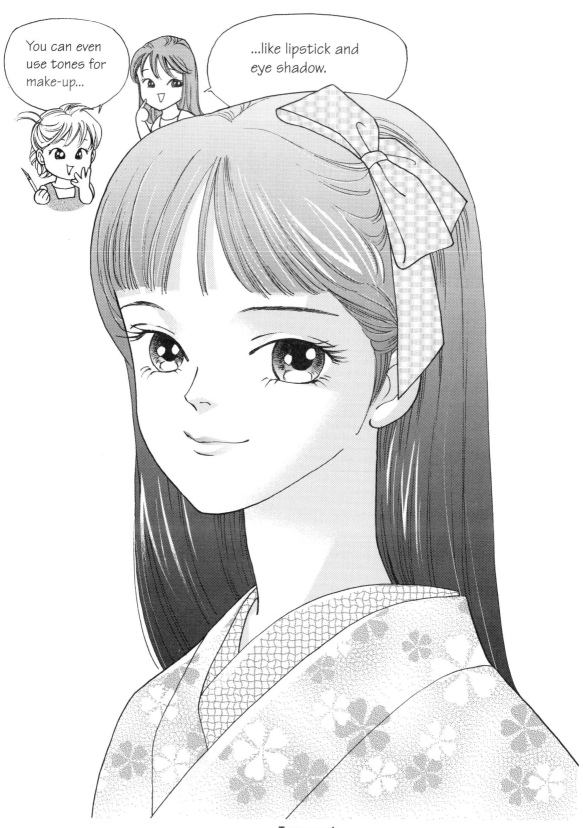

Tones used:
Skin: dots 50 lpi 10%
Hair, eyes and lips: dots gradation 60 lpi
Kimono: fine floral flow 02
Decorative collar: Hatching
Bow: plain fabric 02E

Chapter 1

Tone Basics and Etching

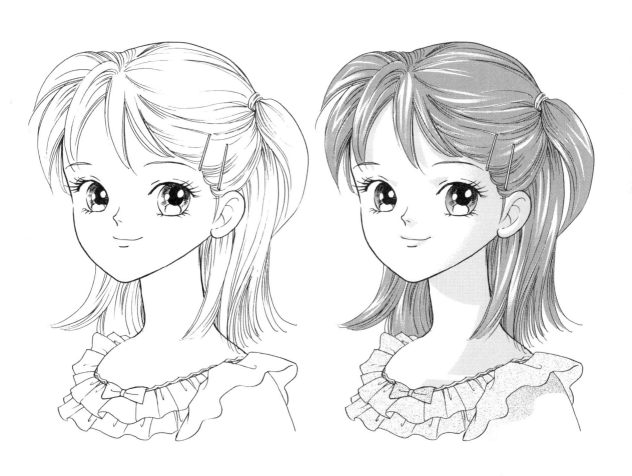

Applying Tones on the PC

Previously, tones had to be applied by hand. But now, we can use computers to greatly reduce the time and effort it takes to use tones, and the range of tone expressions has greatly increased. First, let's learn a little more about tones.

What's a "Tone"?

Tones are made up of black dots, and for the most part are classified according to how may dots they have per square inch. The more dots a tone has, the more it appears as a solid fill, while the fewer it has the closer it appears to white. By adjusting the concentration of dots, then, it is possible to simulate shades of gray.

Applying a tone on a PC

When tones are applied on a PC, not all the work is done on a single illustration. Rather, a separate layer is prepared atop it, and all the tone work takes place there. This makes changes and adjustments easier later on.

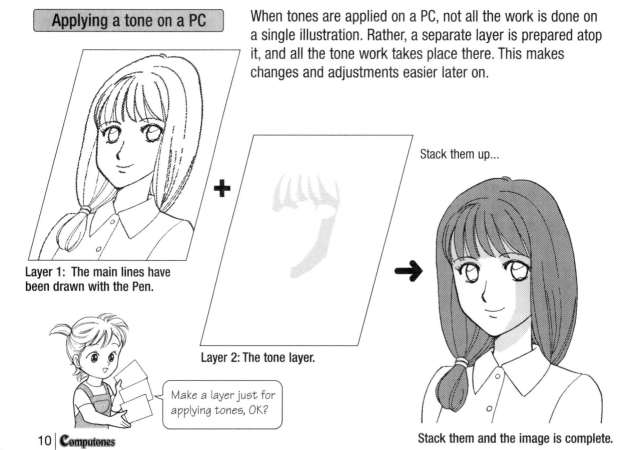

Layer 1: The main lines have been drawn with the Pen.

Stack them up...

Make a layer just for applying tones, OK?

Layer 2: The tone layer.

Stack them and the image is complete.

Try using Computones!

Preliminary check! Are your PC and graphics applications ready to go?

In order to use Computones, you of course need a PC. However, if you have not installed any of the major graphics applications (such as Photoshop), then you cannot use it. Install Computones after you have made sure the graphics application you are using is compatible. The installation process is explained in detail in the manual, starting on page 122.

System requirements:
- Windows
CPU: 500 MHz Pentium3 or better (1GHz Pentium4 recommended)
Memory: 256MB or higher (512MB recommended)
OS: Windows98, ME, SE, 2000, NT, XP

- Graphics Applications (one of the following)
Photoshop 5.0/5.5/6.0/7.0
Photoshop Elements 1.0 to 2.0
Paint Shop PRO 7.0/8.0

❶ Draw your illustration directly on your PC or scan one in.

Point: Whichever method you use, make the actual size of your image 600 dpi or 300 dpi and set the color mode to grayscale.

❷ Open your image with a graphics application.

Point: You open a file by choosing File → Open... and selecting a file.

❸ Select the area to which you want to apply a tone.

Point: Use the Magic Wand from the Tool Palette to select an area for your tone, such as hair or the lower neck. If that selects too much of your image, then go back and do it by hand with the Lasso Tool. By holding down the Shift key you can freely select as many areas as you like.

- We will introduce a technique for deft area selection on the next page.

❹ Start up Computones and apply a tone.

Point: Once you have selected an area, click on Filter → Computones in Photoshop, Photoshop Elements, or Paint Shop PRO to start Computones.

By clicking on whichever tone you like from among those displayed in the album on the right side of your screen, you can see what your image would look like with the tone applied. If you like what you see, then click OK to return to your graphics application.

❺ Save your image.

Point: Save your image after you have finished applying tones to all the areas that need it. If you save your image in the PSD format, which can save your image data as it is while you are working on it, then you can easily modify it later. You might change to another format after consulting with a printing company later on.

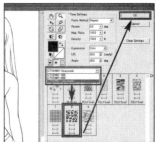

Tone Application Fundamentals and Area Selection Techniques

By using the Magic Wand Tool, Computones can easily apply a tone to your image. However, if there are any breaks in your main lines, then whatever area is bound outside those lines will be selected, and the tone will not be applied properly. So, let's learn some techniques for easy, discrete tone application.

Now what!?

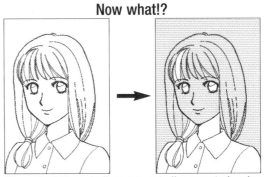

Since the hair main lines are not all connected, using the Magic Wand selects everything all the way in to the background.

Get used to using layers and applying tones.

1. Once you have opened your line drawing in your graphics application, duplicate Background layer to add a new layer (Fig. ❶). Call this new layer "Layer 1."

• How to duplicate a layer:
In Photoshop or Paint Shop Pro, open the Layers palette by selecting Window → Layers, click the button in the upper right to open a menu, and select "Duplicate Layer" (Fig. ❷).

2. On Layer 1, draw a line connecting all the hair lines together where their main lines end (Fig. ❸). This will close them off. Use the Magic Wand to select them (Fig. ❹).

3. Add a new layer, and call this one Layer 2 (Fig. ❺, Fig. ❻).

Go back to Layer 1 and copy the hair section. Move back to Layer 2 and paste the hair section you copied earlier (Fig. ❼).

How to make a new layer:
In Photoshop or Paint Shop Pro, open the Layers palette by selecting Window → Layers, click the button in the upper right to open a menu, and select "New Layer."

4. Now call up Computones for the first time, and apply any tone you like (Fig. ❽, Fig. ❾). The hair tone is now complete. Delete Layer 1, where you drew your guidelines, and you are done (Fig. ❿). The main lines now return to their former appearance, and you have neatly applied your tone. Now save your work as is.
Later, we might consider any alterations. To save the file as a normal EPS or JPEG file, you must "flatten" the layers you have added.

To do this, click on the button in the upper right corner of the Layer palette and select "Flatten Image" from the menu.

Point
By supplementing the lines on a copy and not tampering with the original image, there can be no accidental erasures or tone overapplications on it.

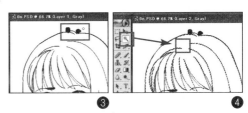

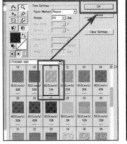

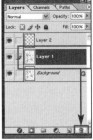

Applying shadow tones

Even when applying shadow tones to the cheek (or really, to any area with no lines), you still have to draw some lines to specify where the tone will be applied. But how do you get rid of those guidelines when you are done? Erase them little by little with the Eraser Tool? Going to such lengths is not necessary. Instead, you can use the techniques introduced previously to simply remove them.

1. Once you've opened the original image, duplicate the Background layer by selecting "Duplicate Layer" from the Layers Palette (Fig. ❶) and call it Layer 1. On Layer 1, draw guidelines with the Pen Tool around where you want your shadows to go (Fig. ❷). Then just as before, use the Magic Wand to select those areas.

2. Add a new layer, and call this one Layer 2 (Fig. ❸). Go back to Layer 1 and copy the shadows you have selected. Once you have moved to Layer 2, paste the shadow sections you copied earlier (Fig. ❹).

3. Call up Computones once again (Fig. ❺), and apply any tone you like (Fig. ❻). The shadows are now complete.

4. Delete Layer 1, where you drew your guidelines, and you are done (Fig. ❼). The main lines now return to their former appearance, and you have neatly applied your tone.

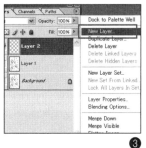

❶

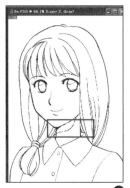

❷

❸

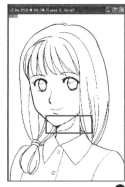

❹

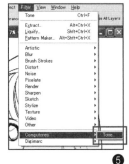

❺

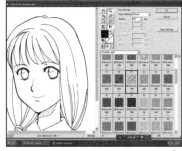

❻

Point
Adding guidelines to a copy lets you work without tampering with the original. Also, since you only copy the areas of the face that needed cheek shadowing, you save time that would otherwise be spent erasing unnecessary lines..

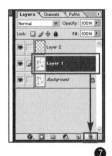

❼

Tone Mechanics

Dot tones, a toning staple, are made up of bunches of dots. By making those dots smaller or larger or by raising their concentration, you can make a color appear darker or lighter.

Handling even dot tones

60 lines 10%
This is a basic shadow color.

60 lines 30%
This is a color for deepest, recessed shadows.

Key words here are "lines per inch" (LPI) and "percentage."

It looks colored, doesn't it?

LPI This represents how many rows of dots there are per square inch. The greater this number gets the more rows there are, the less space each dot takes, and the smaller they appear.

Percentage This represents how much area per square inch is taken up by dots. Since the dots are black, if this figure is low, then the white areas will stand out. The larger it is, the more it seems like a solid fill.

Change the tone and the image changes.

Let's use a 60 lpi dot tone as an example, since it is one of the most commonly used tones, and see what characteristics lpi and percentage represent.

This is a low-percentage (5%) dot tone.

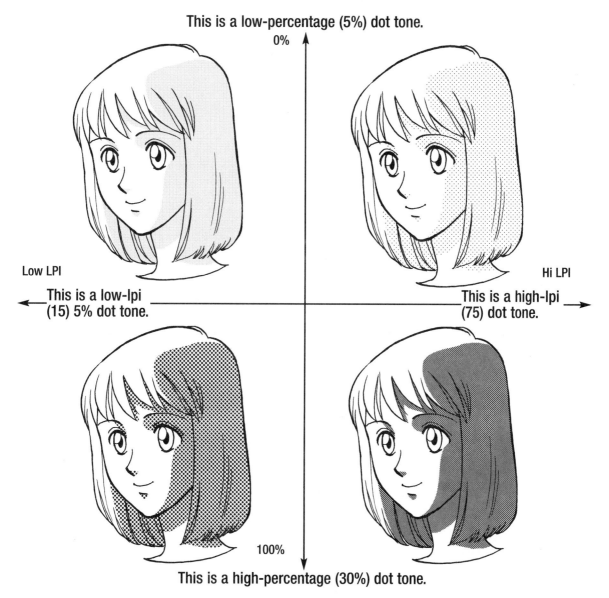

0%

Low LPI

This is a low-lpi (15) 5% dot tone.

Hi LPI

This is a high-lpi (75) dot tone.

100%

This is a high-percentage (30%) dot tone.

So why are 60 lpi 10% dot tones so common?

It is because you can make human skin appear natural with it, and because it keeps the individual dots from getting smothered during printing. You might be able to use a 70 lpi or greater tone with fine high-quality paper. Let's give it a try.

Introduction to Tones: Types and Characteristics

Dot Tones

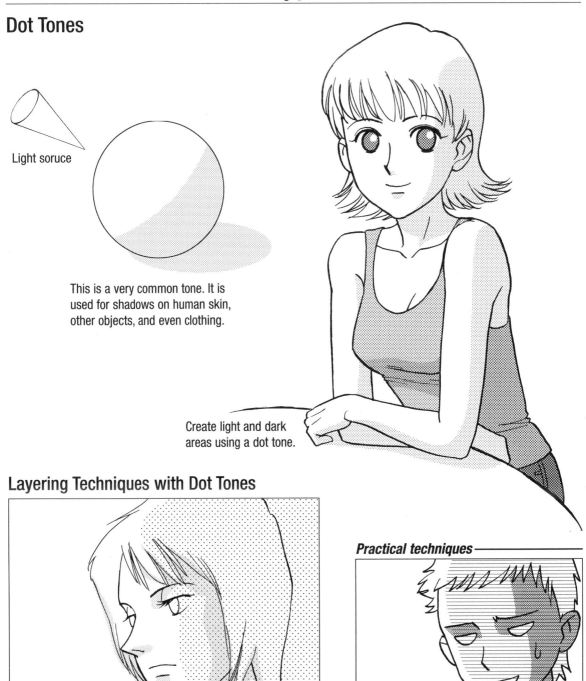

Light soruce

This is a very common tone. It is used for shadows on human skin, other objects, and even clothing.

Create light and dark areas using a dot tone.

Layering Techniques with Dot Tones

Practical techniques

Layer a fine dot tone and a rough one to give a shadow character.

By layering a line tone and a dot tone, you create a sense of imagined scenery.

Gradation tones

Use a gradually darkening harmony and you can make something appear three-dimensional.

Gradation tones have been used here.

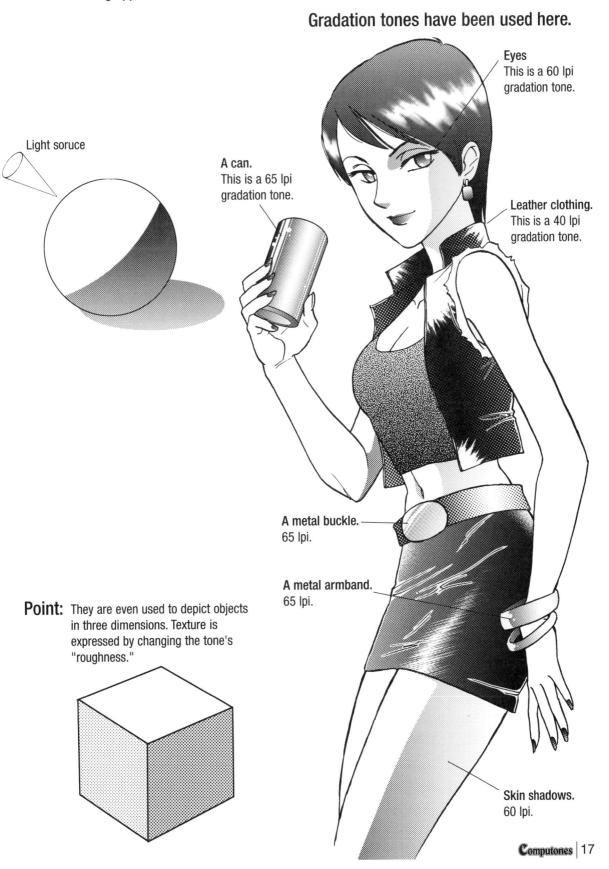

Light soruce

A can.
This is a 65 lpi gradation tone.

Eyes
This is a 60 lpi gradation tone.

Leather clothing.
This is a 40 lpi gradation tone.

A metal buckle. 65 lpi.

A metal armband. 65 lpi.

Point: They are even used to depict objects in three dimensions. Texture is expressed by changing the tone's "roughness."

Skin shadows. 60 lpi.

Sand tones

These tones effect the rough feeling of sand. They are a resource used for the ground or for other coarse surfaces.

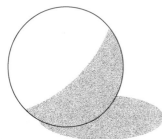

Just by applying the tone, an object is made to appear rougher.

- A sweater. This is a 5% granular sand tone.
- Leather (suede). This is a 75 lpi 10% sand tone.
- The ground. This is a 33 cm dither gradation.

Sand tones are often used like this. This is a 40 lpi 20% sand tone.

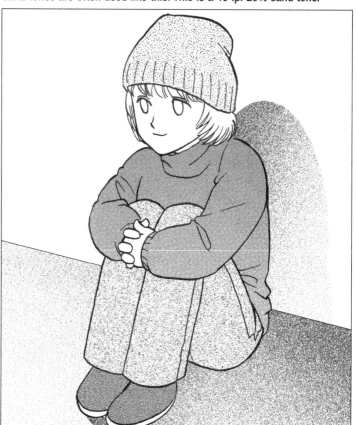

Hatching tones

Aside from having a hand-drawn effect, hatching tones are used to express shades of gray.

They are even used for alligator skins. Try using them as ideas come to you.

- Hair. This is a hatching tone.
- Imagined background scenery. This is a 16.5 cm background hatching gradation.

Hatching tones are often used like this.

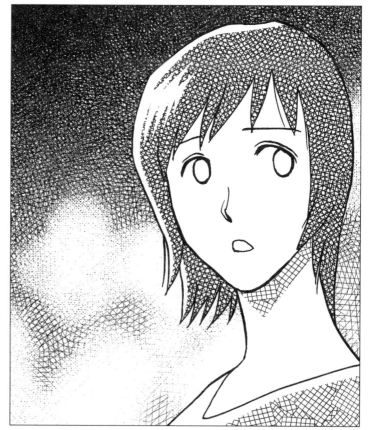

Special effects tones

Used mainly when you want to create a feeling of speed or grabbing the viewer's attention, these tones are indispensable for effecting scenery.

You can express a feeling of speed just by applying a special effects tone.

- Effecting imagined background scenery: a deluge. These are Speed line 01 and Lighting 01 tones.

Special effects tones are often used like this.

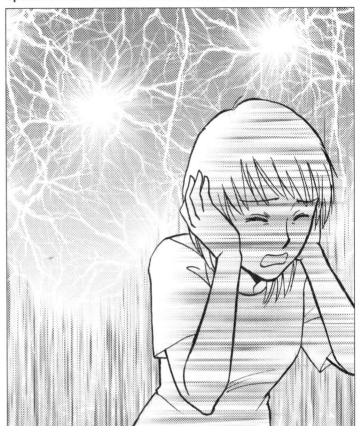

Pattern tones

These tones are used for expressing clothing fabric design patterns.

By applying a pattern tone, patterned object designs become an easy possibility.

- A ribbon. This is a Check 03 pattern tone.
- Floral background. This is a sunflower pattern tone.
- Clothing pattern. This is a Rose 02 pattern tone.

Pattern tones are often used like this.

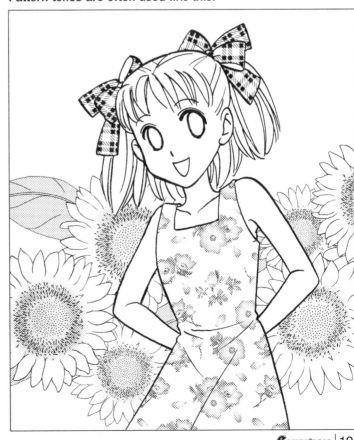

Expressing Human Shadows through Tones

Let's use tones to create human shadows.

Light strength and shadow depth

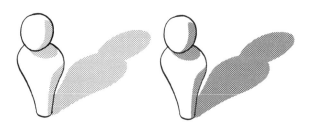

Normal lighting.
This is a 55 lpi 10%
dot tone.

Strong lighting.
This is a 55 lpi 30%
dot tone.

Light

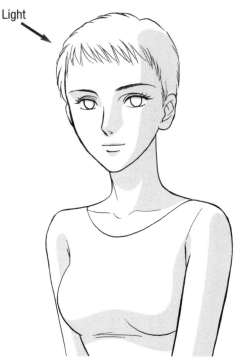

For normal sunlight, use a 55 lpi 10% dot tone.
When the sunlight comes from the upper left, it goes from
the forehead to the cheeks and neck muscles, and so
there the shadows lie.

Light

Light

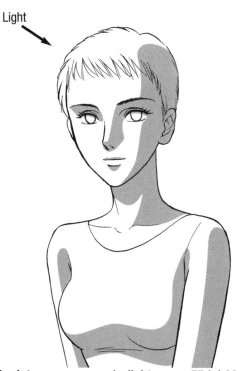

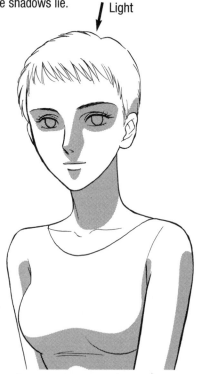

**For intense summer daylight, use a 55 lpi 30%
dot tone.**
Use a slightly denser-than-normal tone to emphasize the
contrast between light and dark.

**When sunlight comes from directly overhead,
use a 55 lpi 30% tone.**
Except for the eyes and neck, sunlight from directly above
makes the shadowed areas narrower and darker.

Effecting dark scenes

Expressing shadows in dimly lit areas

Leaving a highlight around the outline makes the overall image appear gray. A 60 lpi 20% dot tone is used here.

Expressing scenes flooded with backlighting

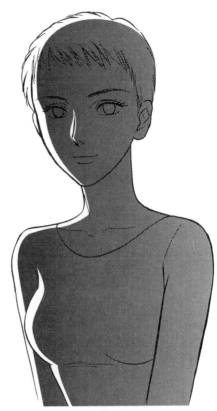

Clearly contrast light and dark, and cut an edge while leaving a highlight around the outline.
A 60 lpi 50% dot tone is used here.

Multiple light sources

Consider the distance from the light sources and their strength, and apply a gradation tone from both directions. In this case, the light source in the foreground is closer, so we are using a lighter gradation tone and a darker gradation tone for the rear light source.

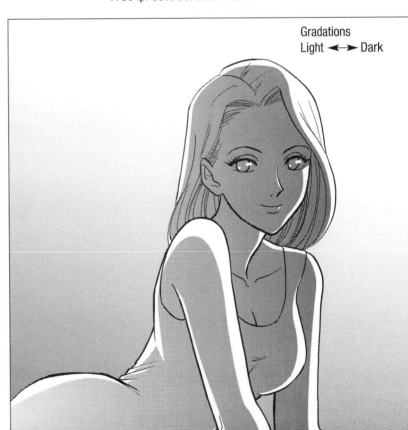

Gradations
Light ◄──► Dark

Creating Shadow Effects through Tones

Depending on where they are cast, shadows on human faces change concentration.
By using tones to create natural shadows, you can increase the 3-D feel of an image.

Human shadows and direction
All tones used are 10% dot tones.

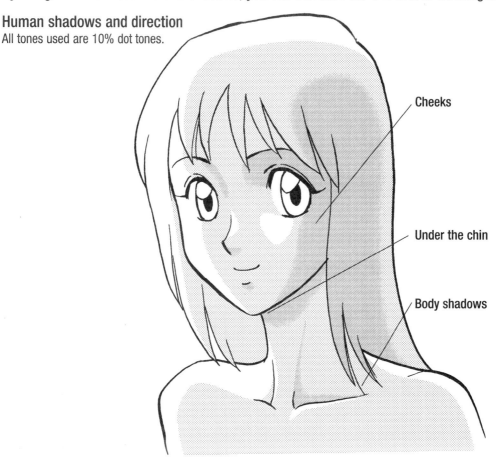

Cheeks

Under the chin

Body shadows

Harmonize shadow depth through gradation tones.
Gradation tones make it easy to harmonize light and dark. When you
use them, lighten the side closest to the light source.

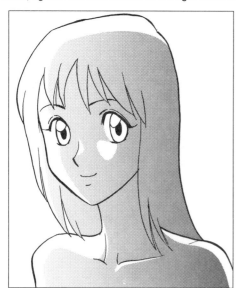

Layering tones: double tone techniques

Tones are not something you can only use one at a time, one type at a time. By layering them you can express deeper feelings.

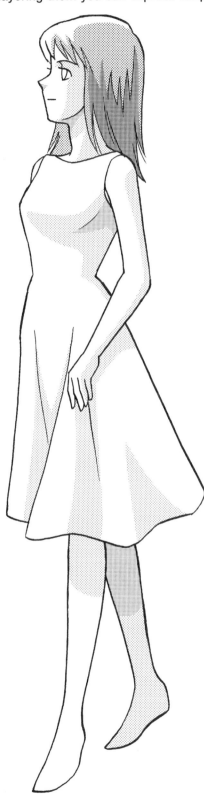

The concentration changes according to how the tones are layered.

20% overlap
−dark

50% overlap
−medium

About 80% overlap
−light

Leave a natural impression by blurring the boundary between tones.

By blurring a tone's edges little by little, you can effect a soft harmony.

You can blur the etching edges of the cheek tone with a dither brush. It would be good to leave the dots faint.

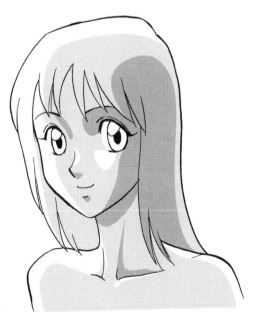

Expressing Highlights with Etching

Express highlighting by etching the tones you applied as shadows.

Tone only

With etching

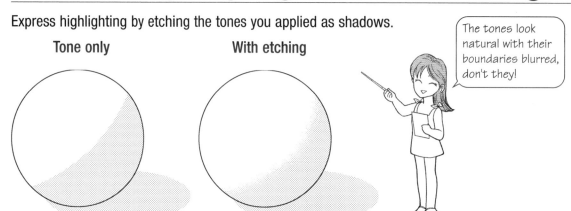

The tones look natural with their boundaries blurred, don't they!

There are two kinds of etching: soft and sharp.

Sharp etching

Soft blurring

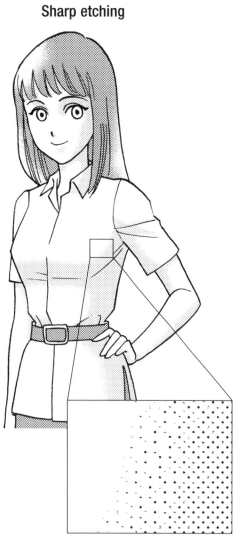

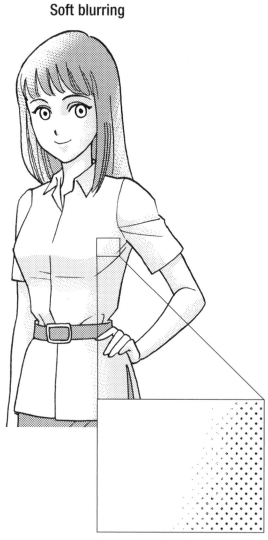

Express sharp highlights by stroking in a straight line.

Leave some light dots behind as though they had been scattered about and effect a soft image.

Make sharp etching look clean.

Express a natural feel by repeating smaller strokes. Adjust the line thickness and etch without any irregularities.

Clean etching

The etched sections are all lined up.

Sloppy etching

Maladjusted thickness and length make for a messy image.

Clean stroking is all in the angle.

The key is in how many dots you leave while you're stroking. Straight lines at an angle somewhere between 45 and 90 degrees can show the cleanest etching.

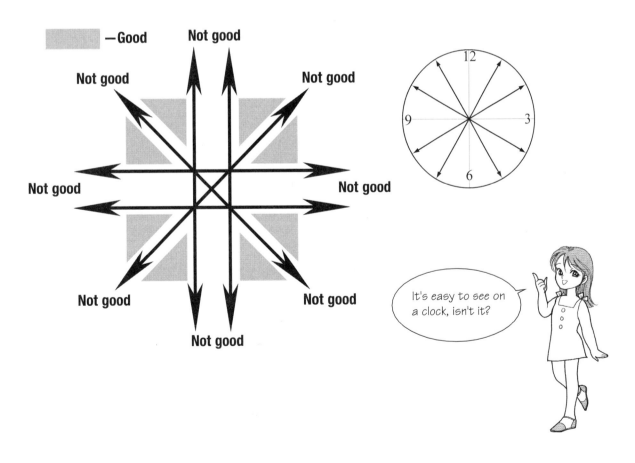

Easy Methods for Sharp Etching

Drawing a straight line is unexpectedly difficult. So, let's use the included tones and turn them into a sharp etching tool.

The spokes in a rendering line tone are done with a brush.

❶ Apply a rendering line tone (Flash Effect Line 01) to a 600 dpi image.

❷ Use your graphic application's Magic Wand function to select one spoke of the tone as you like, and copy it.

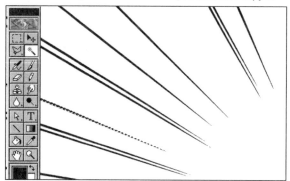

❸ Use the Rotate → 180 deg. function, and narrow either the right or left side to a point.

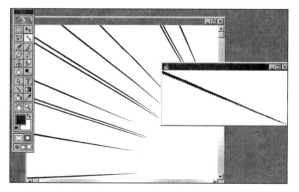

❹ How to register brushes:
For Photoshop4.0/5.0/6.0/7.0/CS&Photoshop Elements 1.0/2.0
Select All to select the entire image. Select Edit → Define Brush..., give your brush a name, and save it.
For Jasc Paint Shop Pro 7.0/8.0
Choose Selections → Select All to select the entire image. In the Paint Brush Tool Options bar, select Custom from the Pen Mark menu.Click Create and call up your brush. Finally, hit OK to save your brush.

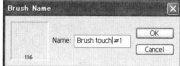

Incorrect

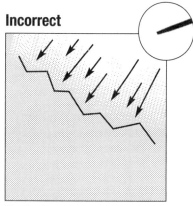

The basic spoke shape is like an arrowhead.

Correct

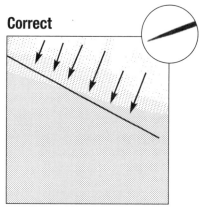

Make the shape of your tone sharp, like a pin. Doing so leaves the spoke looking tapered.

This scene is set up such that it is bathed in sunlight from the upper left, and there is some fine sharp etching on the human shadows as well as those on the clothing. By using a spoke-shaped brush, you can easily etch cleanly and at the correct angle.

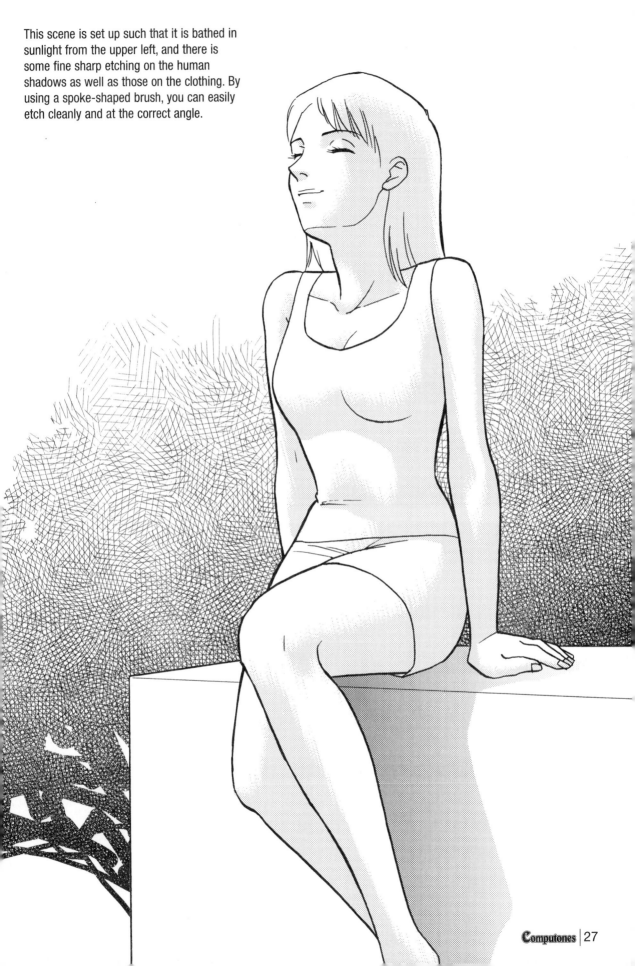

Sharp etching techniques 1

Using Different Brushes, Large and Small

Etching with a small spoke brush

Make your spoke brush about 5 cm long, and use it to add highlights to the detailed areas of faces or clothing.

It is effective to use a wider brush for rough dot tones and a finer brush for fine ones.

Etching with a large spoke brush

You can also use this with speed lines to effectively present a scene, or with straight-line highlights (such

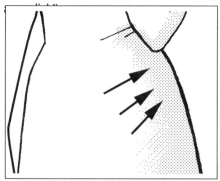

There are a variety of ways to use straight lines, triangles, etc. It's all up to your creativity. Learn how to adjust your hand strokes, and aim for clean etches.

Sharp etching techniques 2

When doing fine etching along an outline, keep in mind the position of the light source and use a small brush to add highlights.

❶ If you are etching a face, keep the flow of the outline and facial curves in mind.

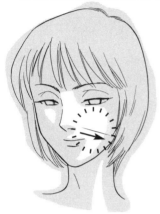

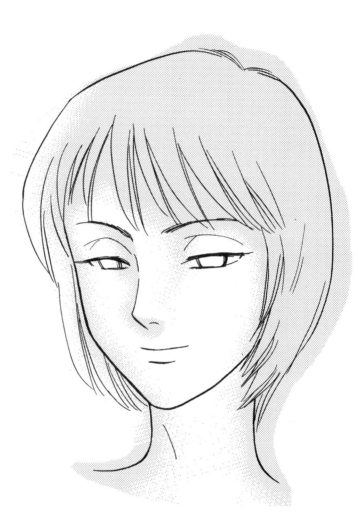

❷ Consider light and dark areas separately.

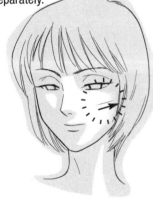

❸ Etch with the angle of the light as it comes from the source, and then etch in the direction of any reflected light.

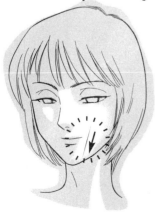

❹ Since the light here is coming from three angles, make three brushes, one for each angle.

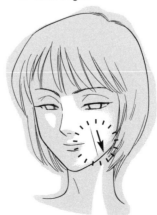

Expressing Soft Blurring

Using the sharp brushes you have already made, create brushes for soft blurring.

❶ Either draw several tapering parallel lines with pen and paper, or connect a pressure sensitive tablet to your PC and use the Shift key to draw several parallel spindle-shaped (tapered at either end and slightly wider in the middle) lines.

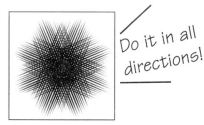

Do it in all directions!

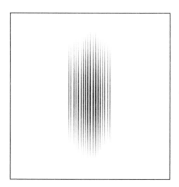

❷ As you use the Gauss filter to blur the lines, select Edit → Skew and extend them.

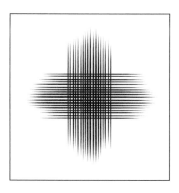

❸ Copy the line and Paste them in multiple rows of roughly the same length.

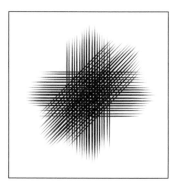

❹ Copy them again, Paste them, Rotate them 90 degrees, and layer them on top.

You can make brushes by rotating the lines!

Stroke and pull off the brush where you want to highlight, and you will etch and lightly blur the dots there. To repeat this, you can either stroke the brush again, or set the spacing on the brush to between 50 and 90%. In that case, you will etch the tone as though you were tapping it. Strong strokes can easily smear the dots.

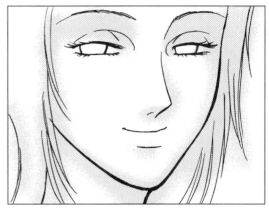

By using the brush at the tone's edge, you can blur the lines between light and dark for a natural blending effect.

You can achieve a clean blur effect in all directions.

Not good

Good

Airbrush blurring

The edges of the tone appear as a gradation and you can clearly see their boundaries.

Soft brush blurring

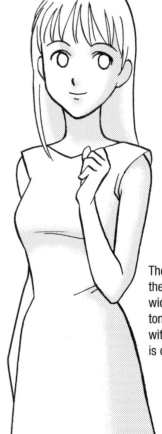

The dots at the edge of the tone are etched over a wide area, and so the tone boundary appears with a natural finish and is difficult to see.

Blur brush techniques 1

Techniques for Applying Small Blurring Brushes

By preparing a small brush in advance when you start to create a blur brush, you can effect fine expressions.

At 600 dpi make your brush 5-20 cm big. Change the brush size and the stitching.

Use it to show a sheen on soft clothing or a shine on other items.

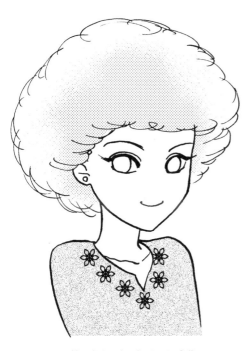

Use it to give luster to full, soft hair.

It'd be a good idea to make a bunch of different sizes in advance!

Use it for silhouettes, or for the unique curves of the female body.

Blur brush techniques 2

Techniques for Applying Large Blurring Brushes

By making a large brush, you can effect imagined scenery or use the brush in a variety of other scenes.

Use it to create blurred scenery, as if a fog had rolled in.

You can also use this blurring effect to draw attention to an area.

Use it together with direct sunlight to create a diffuse effect.

Blur brush techniques 3

Blur brushes using a sand hatching tone

There are brushes that you can use for soft blurring other than those with line tones. By using a hatching tone, the dots become easier to etch away. The key to using them is not to drag, but rather to use the brush like a stamp.

❶ Use a 40 lpi sand hatching grain gradation tone.

❷ Cut some out and register a new brush.

By using a hatching tone as a brush, you can leave some dots and etch out others.

This could also be done with an airbrush, but this way you can etch and leave the dots behind for a clean finish.

Other blur brushes 1

Let's try looking around at the other included hatching gradations and see what we can use.

100%

200%

These can be used to blur images, and can be used for both light and dark applications.

Other blur brushes 2

You can also use flash fill tones for your brushes. Shrink flash fill 11 down to 25%.

Reverse the tone, and register your brush.

Use the brush in a tapping fashion. Try out a few different approaches.

Etching tip

One key to etching is "pulling up." Pulling up gives your etching a clean finish. Your etching pattern figures into it as well, but the expression you achieve will change depending on if you make fine, careful strokes or strong, quick ones. So try making brushes using a variety of different tones.

More elaborate tone work

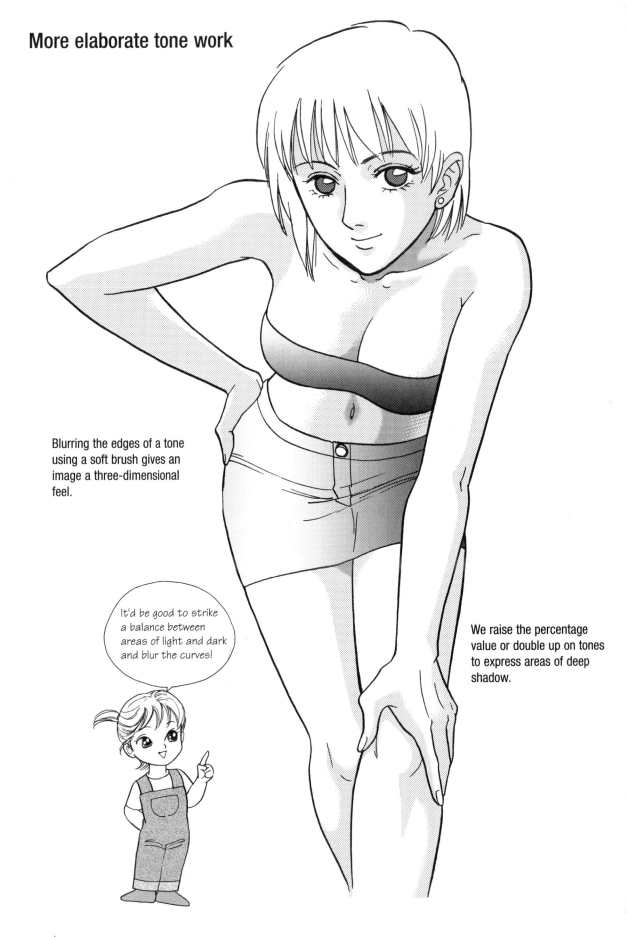

Blurring the edges of a tone using a soft brush gives an image a three-dimensional feel.

It'd be good to strike a balance between areas of light and dark and blur the curves!

We raise the percentage value or double up on tones to express areas of deep shadow.

Chapter 2

Techniques and Practices in Tone Expression

Facial Shading and its Application

The face is one of the most often drawn areas, and these techniques are necessary for making facial shadows and expressions look three-dimensional.

Although they can change depending on the position of the light source or according to the situation, let's get a grasp on the fundamentals of shading and use them in a few different settings.

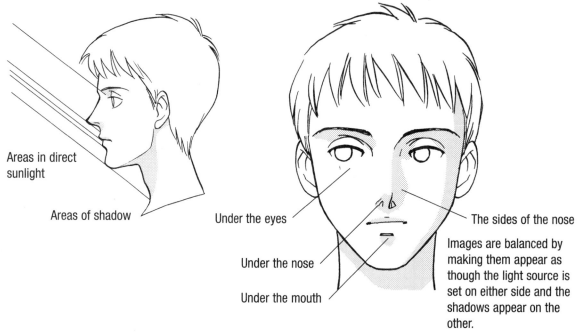

Areas in direct sunlight

Areas of shadow

Under the eyes

Under the nose

Under the mouth

The sides of the nose

Images are balanced by making them appear as though the light source is set on either side and the shadows appear on the other.

Applying shadows to the entire body

This is totally totally black!

Not good
By applying too much shadow it turns into a dark image. It's important to focus on where to shadow.

Good
If you are showing off the entire body, then don't stress facial shadows. Instead, let's think about how to add shadows such that the image fits the situation.

Several different expressions of facial shadow

For realistic faces

To show the delicate musculature of the face, use no main lines and instead express them in shades of light and dark.

Expressions of age difference in facial shadow

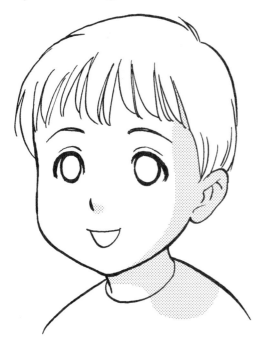

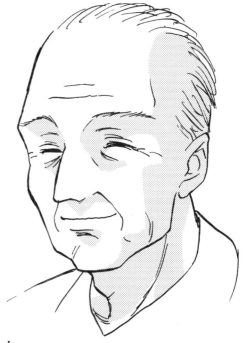

Children
A child's face and body look more realistic when drawn rounder. Applying tones in curves to match that roundness therefore creates mood.

Elderly
Generally, the elderly face and body type are thinner and bonier, and so unlike children, apply tones straight lines and edges.

Using Tones to Express Facial Features

The impression that a character's expression leaves can change just by changing the way you apply shadows to it. It is especially important to know how to deal with tones as they apply to the most prominent features of the face: the eyes, hair, nose, and mouth.

Eye toning processes

The eyes are roughly divided into two parts: the pupils and the irises. Normally, you would apply a dot tone, but a gradation tone is also applicable. By applying a solid fill or operating only on the gradation, the eyes leave a subdued impression.

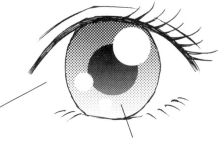

Pupils
They are center of the eyes. Just filling them in can easily make them appear cold, so instead create expression by applying a gradation and drawing in other details.

Irises
They are the areas surrounding the pupil. They are usually expressed in a lighter color than the pupils.

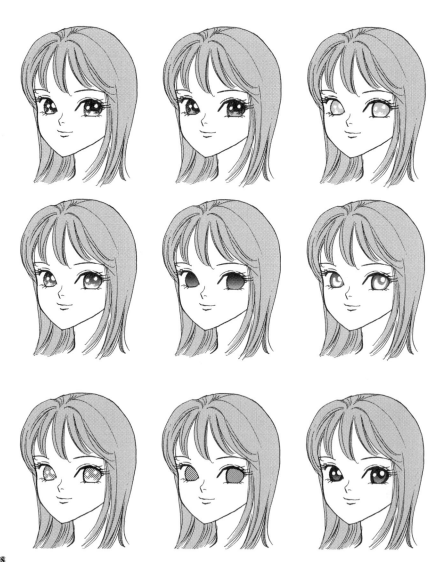

Hair toning processes

The impression hair gives off changes depending on whether you add etching to highlight it a lot or whether you use finer processing to highlight it a little. It's also possible to express the flow and lay of hair through broad etching at the top of the head, but this kind of work demands patience.

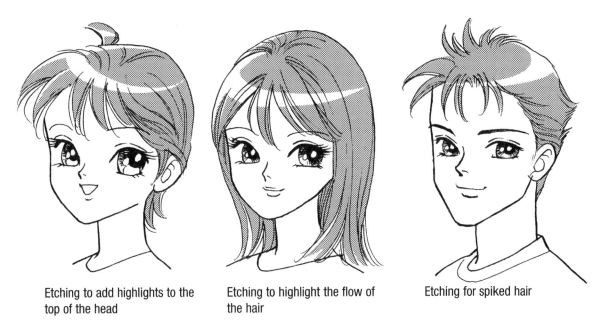

Etching to add highlights to the top of the head

Etching to highlight the flow of the hair

Etching for spiked hair

Nasal toning processes

Shadows around the nose are often done with solid fills as a matter of preference, but at times when the shadows cover a larger area, tone processing is also done. In such cases, effect depth by applying a dot tone or a double tone.

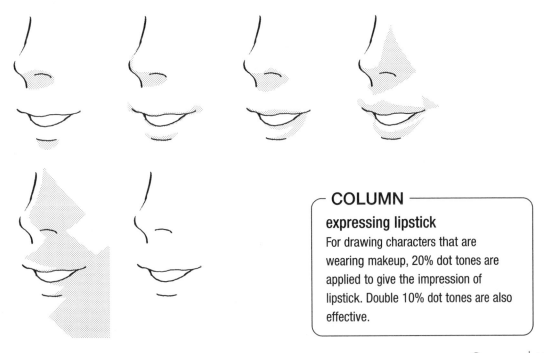

Hand & Leg Toning Processes

Like the face, the hands play a major role in expressing a character's feelings. So, you should know tone techniques for handling shadow applications according to gender, age, etc.

Hand toning processes

"Hand" shadows are made up of finger shadows. As you apply tone along the outline of the hand, draw lines in advance around the joints with a pen to emphasize them, making them look like the real thing.

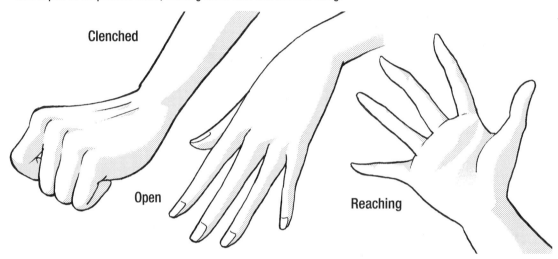

Clenched

Open

Reaching

Use tones to express hand movement.

As the hand has a complicated structure, the shadows it creates change depending on the location of the light source. However, since the hand is also the easiest practice subject, let's look further into on how to shade them.

A hand holding a pen

A grasping hand

Two hands with fingers interlaced

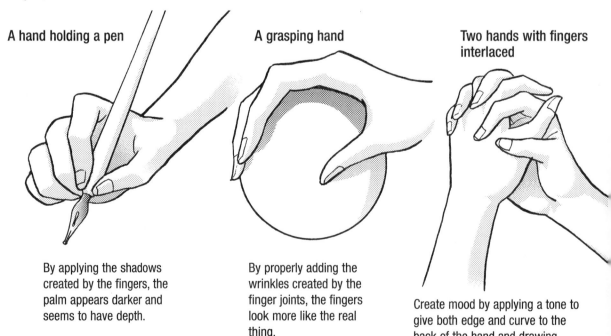

By applying the shadows created by the fingers, the palm appears darker and seems to have depth.

By properly adding the wrinkles created by the finger joints, the fingers look more like the real thing.

Create mood by applying a tone to give both edge and curve to the back of the hand and drawing wrinkles at the base of the hand.

Leg Toning Processes

Legs are usually clothed and not often exposed. However, there are may still be plenty of chances to draw them depending on the story. Just as with the hands, keep in mind that male legs have a muscled look, while it's important that female legs have a curvaceous form to them.

A bent leg

Create a line running from the thigh to the calf. Males get a nearly straight line, and females should get a curvy one. One detail you should emphasize is the shadow at the back of the knee.

Female legs

These delicate legs are central here, so only apply a tone where shadows clearly lie, and be careful not to apply too much.

Male legs

If you are dealing with muscular male legs, then there are shadow areas from the muscles of the thigh to the kneecap, and from the shin around to the calf. It would be good to highlight these points broadly and clearly so they stand out.

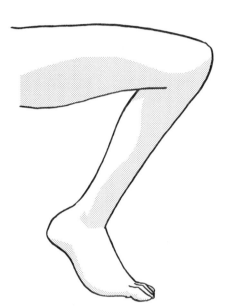

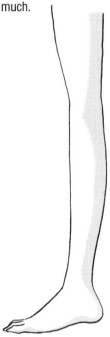

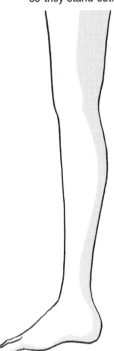

Expressing shoes

Unlike legs, shoe expressions change according to their material. Let's take a look at how to process shoe tones on three typical examples.

Sneakers

Aside from the mesh portions, you basically tone a sneaker with a dot tone, separating sections via concentration as you apply it.
Tone used: Gradation tone 60 lpi
16.5 cm

Pumps

Use a gradation tone to express the leather in these shoes, and add highlights in parts for the toes, heel, etc.
Tone used: Gradation tone
60 lpi 6.6 cm

Patent leather boots

As these shoes are made of a shiny material, add highlights cleanly to the cylindrical portion.
Tone used: Gradation tone 60 lpi
2.2 cm

How to Apply Tones to the Body

Apply body tones with the same understanding of where shadows lie. There aren't many differences in location between the male and female, but males tend to need more tone where the shadows lie across muscle.

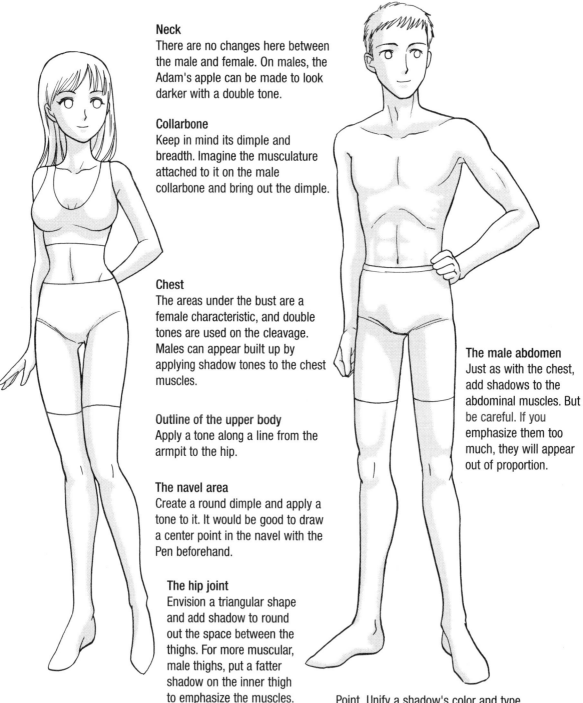

Neck
There are no changes here between the male and female. On males, the Adam's apple can be made to look darker with a double tone.

Collarbone
Keep in mind its dimple and breadth. Imagine the musculature attached to it on the male collarbone and bring out the dimple.

Chest
The areas under the bust are a female characteristic, and double tones are used on the cleavage. Males can appear built up by applying shadow tones to the chest muscles.

Outline of the upper body
Apply a tone along a line from the armpit to the hip.

The navel area
Create a round dimple and apply a tone to it. It would be good to draw a center point in the navel with the Pen beforehand.

The hip joint
Envision a triangular shape and add shadow to round out the space between the thighs. For more muscular, male thighs, put a fatter shadow on the inner thigh to emphasize the muscles.

The male abdomen
Just as with the chest, add shadows to the abdominal muscles. But be careful. If you emphasize them too much, they will appear out of proportion.

Point Unify a shadow's color and type
Depending on the body part, you can use a gradation tone to make certain areas appear darker. But if you apply different gradation tones at different lpi's or percentages, then your image will look sloppy. Use just one or two types separately instead.

Expressing Musculature through Tones

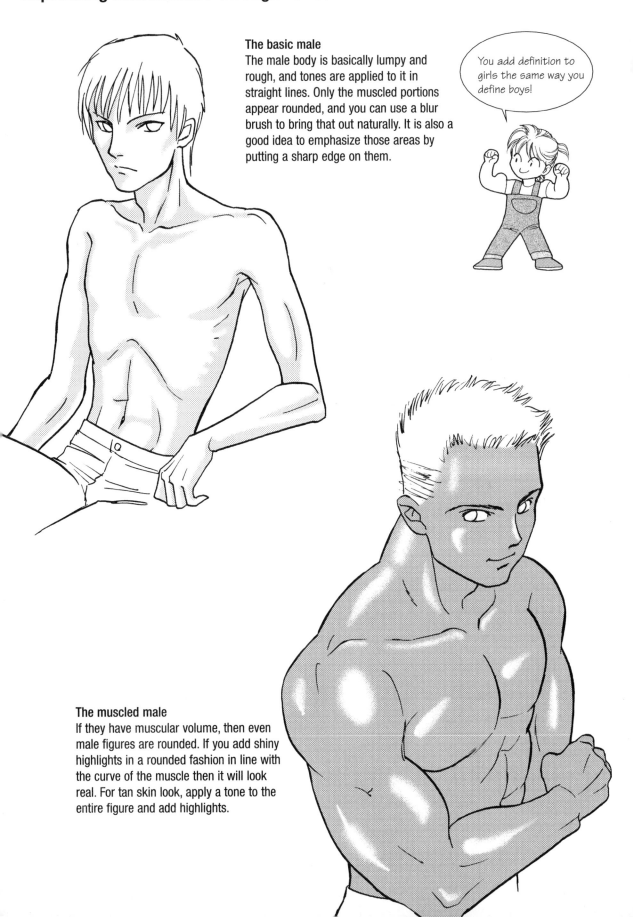

The basic male
The male body is basically lumpy and rough, and tones are applied to it in straight lines. Only the muscled portions appear rounded, and you can use a blur brush to bring that out naturally. It is also a good idea to emphasize those areas by putting a sharp edge on them.

You add definition to girls the same way you define boys!

The muscled male
If they have muscular volume, then even male figures are rounded. If you add shiny highlights in a rounded fashion in line with the curve of the muscle then it will look real. For tan skin look, apply a tone to the entire figure and add highlights.

How to Use Tones to Express Patterns in Clothing

A variety of pattern tones (floral, geometric, etc.) have been prepared, and they are used most often for clothing. By skillfully using pattern tones, you can save yourself some drawing and easily express a character's sense and preferences at the same time.

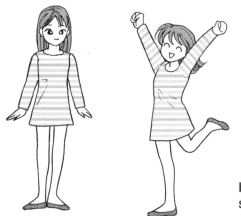

Just applying a pattern tone looks weird!
Even if a pattern tone has pictures drawn in it, it's still a flat image, and it won't look three-dimensional applied as is.

It is important to apply the tones separately according to each joint.
Just as with actual clothing, the direction of clothing patterns changes according to how the arms, legs, and body move. If the arm bends, then you should change the direction of the tone accordingly.

Techniques for mastering pattern tones

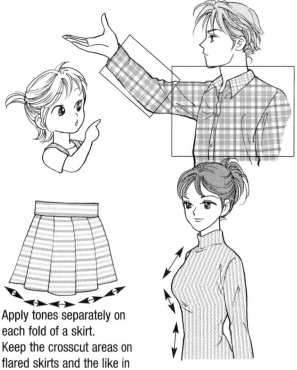

Change angles and apply tones separately according to the part of the body.
Change the angle of the pattern on the collar to be different from that on the chest.

Apply tones separately on each fold of a skirt.
Keep the crosscut areas on flared skirts and the like in mind as you do this.

Apply tones separately on the irregularities of the body
Apply a difference in depth to make a female's breasts appear fuller and emphasize their size.

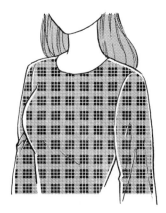

Trace and outline around strong, bold patterns to subdue them.

Effecting Movement by Wrinkling Clothing

One key to make clothes look real is wrinkling. Depending on how much clothing is wrinkled, it can appear either baggy or tight fitting. Wrinkles can be drawn in at the pen stage, and then by applying a tone on top of them, you can make them look more like the real thing.

How to make wrinkles

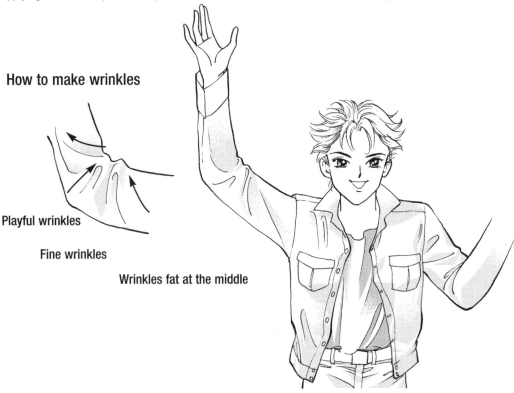

Playful wrinkles

Fine wrinkles

Wrinkles fat at the middle

The difference in making wrinkles from the fabric

For hard fabrics

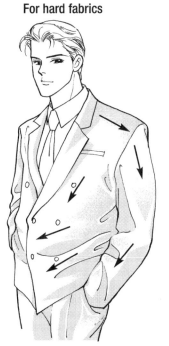

For suits and other thick fabrics, the fabric itself will very much appear to be pulled by body movement, and so the wrinkles must also be straight.

For soft fabrics

For clothing made up of thin fabrics, such as sweaters or sweatshirts, the bagginess allows wrinkles to form easily, and they take a downward flowing shape.

Expressing Body Motion with Tones

To express body motion, it is easier to create an image of motion by using speed lines, line tones, and speed line tones along with the motion of the body. Etch and flow along with the movement, and doing so with a variety of sharp etching brushes rather than blur brushes is a key point.

Twisting around

As you create an image of twisting speed, sharply etch the movement lines. Broadly apply a tone and etch it roughly to bring out energy.

Tone used: Dot tone 50 lpi 10%

Running: shadow processes

A running character's shadows are sometimes displaced somewhat to elicit a feeling of speed. By either etching the shadowed areas with a sharp brush or by applying speed lines, you can suggest a greater feeling of speed than by working directly on the body.

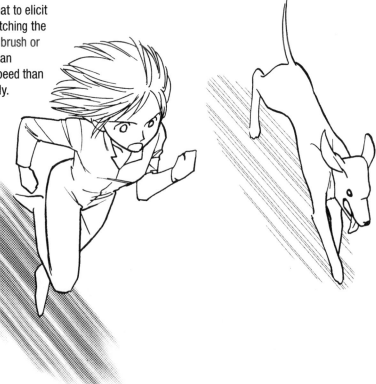

Tone used:
Parallel line tone 02

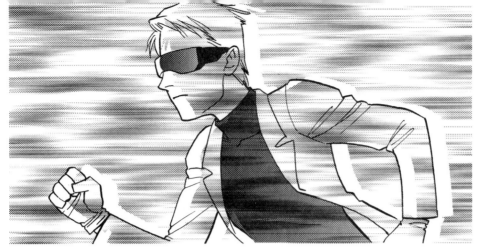

Running: expressing a full-tilt dash

Parallel line tones are used when you want to effect a sense of total speed. Since simply applying the tone as is would make the image difficult to see clearly, the lines must be made not to intersect any people or objects in the image. Those sections are removed by whiting them out.

Tone used: Parallel line tone 01 and Speed line tone 01

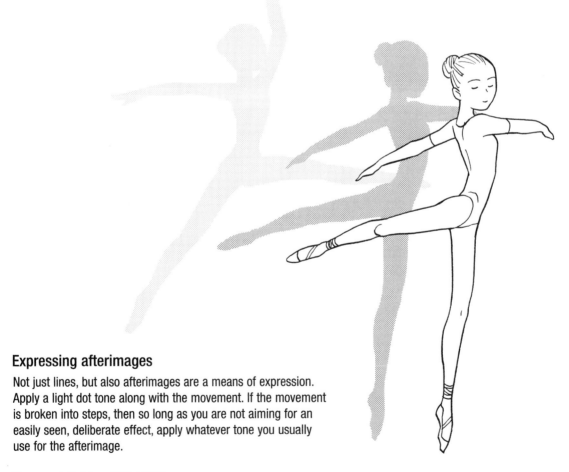

Expressing afterimages

Not just lines, but also afterimages are a means of expression. Apply a light dot tone along with the movement. If the movement is broken into steps, then so long as you are not aiming for an easily seen, deliberate effect, apply whatever tone you usually use for the afterimage.

Tone used: Dot tone 60 lpi 10%

Tone effects 1

Expressing Sunlight with Tones

There are ways that are often used to effect light, such as the strong morning or afternoon sunlight. The key is to add stress (strength and weakness) to the sunlight, thereby increasing a scene's expressive power.

Tips for expressing sunlight

When you apply or etch a tone for sunlight, the image changes according to how you present the highlights. If you are applying a tone, using it as is will make the light appear black, so reverse the color and use it as a white line.

Expressing sharp sunlight

Straight lines give the impression of intense sunlight. Apply a line tone or a rendering line tone and finish it off by sharp etching the details.

Expressing sunlight with soft blurring

Keep the actual rays of sunlight subdued, and light the scene with diffuse reflected light in the surrounding area.

Indoor expressions

Indoors, sunlight often comes through glass, and so the light itself appears softer. Let's introduce some commonly used techniques.

Expressing brilliant light

Express sunlight by adding a glimmer for the reflection off the glass.

Expressing contrast

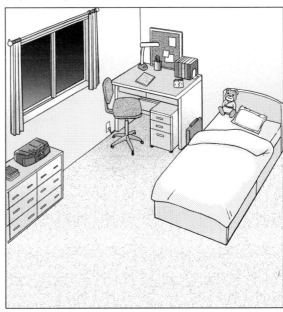

Express the differences between exterior brightness, interior darkness, and an objects shadow through contrast.

How to express tortoise shell

Use tortoise shell when you want to express reflected light and glimmer.

Create a hexagonal shape with a line tone.

Create and layer multiple copies of the same shape and combine them.

Insert the same hexagonal shape on the inside as well.

Tone effects 2

Expressing Artificial Light with Tones

Artificial lights and neon are the mirror opposites of natural sunlight. Master techniques for expressing light in the dark, such as using intensity to make light appear as though it emerges from the background.

Soft bicycle lights

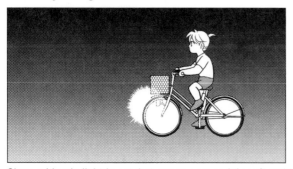 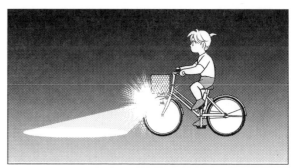

Since a bicycle light is not that strong, use mainly soft etching rather than sharp. Use short, sharp etching strokes around the light to blur it and make it look real.

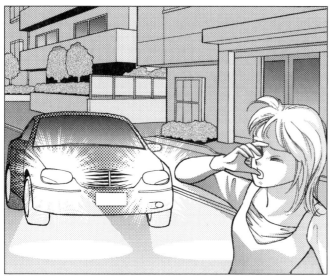

Strong car headlights

For cars equipped with powerful headlights, expressions of intense light make them look real. Use repeated, long, sharp etching strokes and blur the area around the lights appropriately.

Expressing flowing light

You can make an object appear to have moved by etching broadly along with the flow of light. If you etch wide with the object's movement, then the image appears to be momentary. Thinning the etching down results in a rapidly moving image.

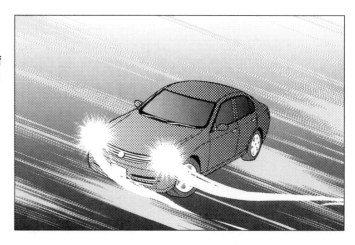

Expressing neon and streetlights

Streetlights and neon signs are indispensable in expressing night city scenes. Basically, bring these out through whiting and blurring.

A soft light

Bring out the area around the light with slightly broader whiting, and etch it with a blur brush to leave a bit of faint light.

A strong light

When you bring out the area around a light through whiting, add shadow to the light source and etch around it with a sharp etching brush.

ABC 1 2 3 I M X

ABC 1 2 3 I M X

How to make lighted letters

Express a soft glow (like a fluorescent light) by whiting the area around the letters and etching a soft blur around that.

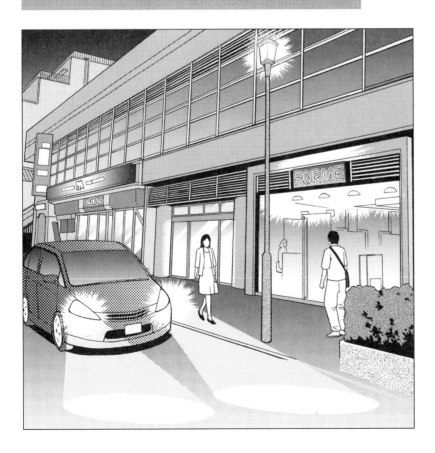

Tone effects 3

Expressing Shine and Sheen

Shine and sheen are important elements in achieving a feeling of depth. By recreating a shine that matches the qualities of a given material you can create a better image.

Types of shine and sheen

Shine in line tones
Etch with a spoke brush at an angle nearly perpendicular to the line.
Used on: metal objects with rounded surfaces, pipe, tubes, etc.

Shine and sharp etching
Etch at an angle nearly parallel to the shine lines.
Used on: everything

Shine and soft blur etching
Make sure what you leave behind after etching is even.
Used on: everything

Shine and gradations
If you adjust breadth of the gradation properly, no etching is necessary.
Used on: cans, walls, hallways, granite

Shine used sparingly
Add clear shine highlights with the Pen.
Used on: plastic, wet roads

Shine and matte finishes
Use a composite dither brush and leave hardly any dots behind.
Used on: ground surfaces, wall surfaces

Glossy and matte materials

Gloss

A: Metal
B: Hard Plastic
C: Steel
D: Glass
E: Rubber
F: Soil
G: Concrete
H: Silk (clothing)
I: Nylon (clothing)
J: Plastic

No gloss

Let's give a shinny, glossy look to a surface.

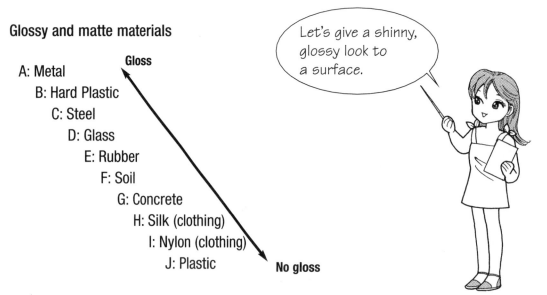

Expressing shine on precious metals

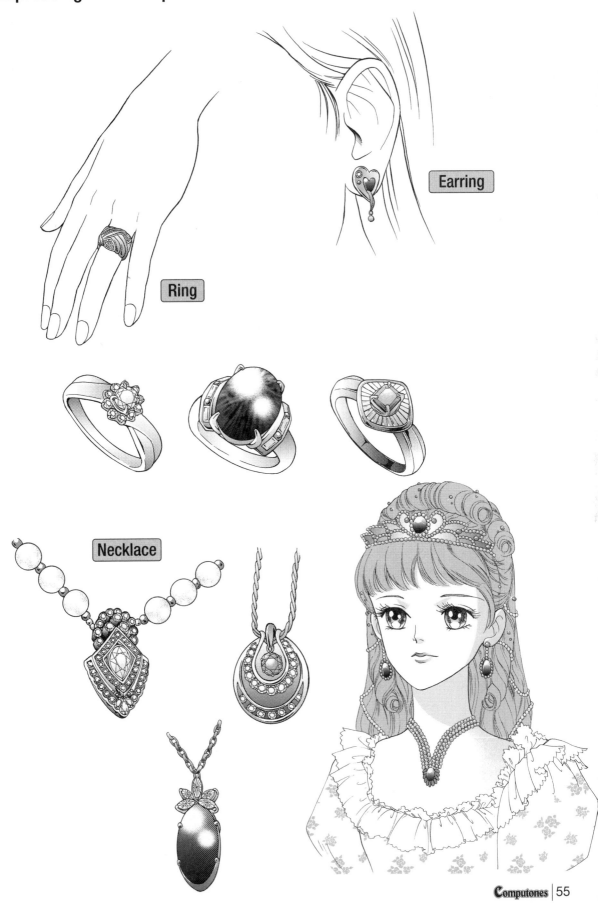

Ring

Earring

Necklace

Tone effects 4

Make-up through Tones

Make-up is an important element of the adult female character. When you use a tone to effect make-up, using the same tone you used for shadowing will make it difficult to tell the two apart, so let's change the tone's nuance and then use it.

Expressing lips

Lips with a glossy sheen
To add sheen to a tone, add one point of light to a weak tone after you apply it.
Tone used: Dot tone 60 lpi 20%

Lips with a matte texture
Apply a slightly deeper tone. To produce sheen, add fine lines.
Tone used: Gradation tone 65 lpi

Expressing the eyes

Making up the corner of the eye
Apply a tone from the corner of the eye to the outer edge. Using a deep tone will make it stick out considerably, so use the lighter part of the gradation.
Tone used: Gradation tone 65 lpi

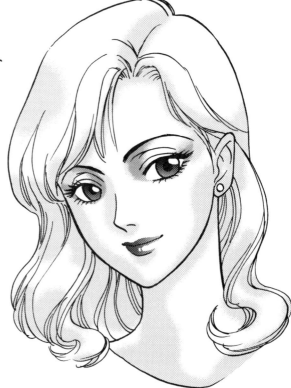

Making up the eyelids
Apply a light tone from the eyelids to the eyebrows. Do not simply apply it to the entire image, but rather with a curve, and blur it just a little.

Make-up patterns

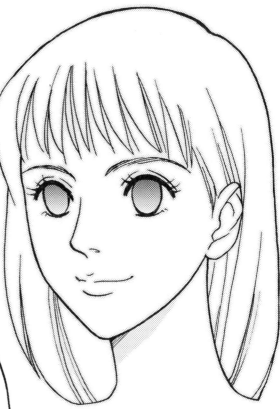

Natural make-up
Apply a weak dot tone to the lips for a lipstick look.

The classy lady type
You can get a soft focus-like effect by placing dots atop the line and blurring them.

The female adult type
Use an slightly deep tone overall, but if you don't hold back a little on the eyes, lips, and other key points then it will look gaudy. If you want to emphasize those points, try going over the lines of the cheekbones ahead of time with a pen for a more realistic look.

Tone effects 5

Expressing Translucent Clothing

You can effect a translucent image for characters in light clothing
or in clothing made from see-through materials.

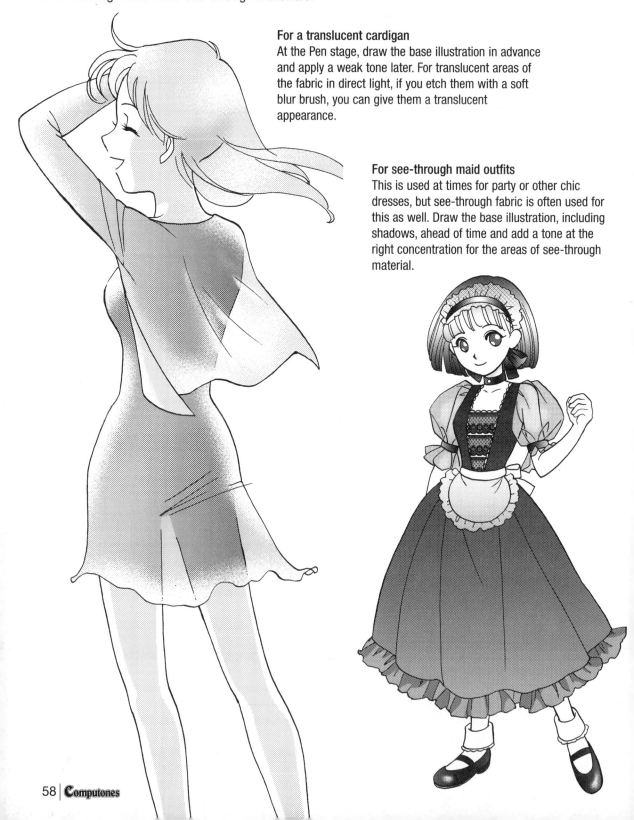

For a translucent cardigan
At the Pen stage, draw the base illustration in advance
and apply a weak tone later. For translucent areas of
the fabric in direct light, if you etch them with a soft
blur brush, you can give them a translucent
appearance.

For see-through maid outfits
This is used at times for party or other chic
dresses, but see-through fabric is often used for
this as well. Draw the base illustration, including
shadows, ahead of time and add a tone at the
right concentration for the areas of see-through
material.

Expressing Color through Tones

The manga world is a black and white one, but by using tones you can create the appearance of intermediate grays. Even for reds and blues, by applying the inherent characteristics of each color, you can express them through tones.

Color and three types by concentration for tones

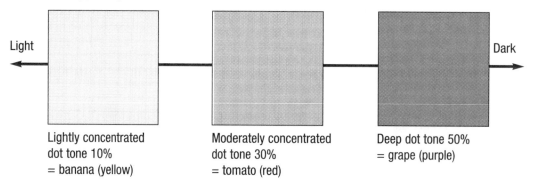

Light ←

Dark →

Lightly concentrated
dot tone 10%
= banana (yellow)

Moderately concentrated
dot tone 30%
= tomato (red)

Deep dot tone 50%
= grape (purple)

Tone color guides

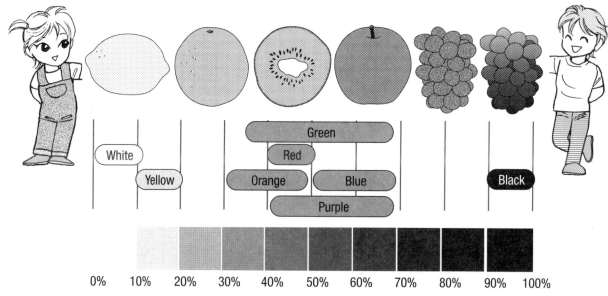

White

Yellow

Green

Red

Orange

Blue

Purple

Black

0% 10% 20% 30% 40% 50% 60% 70% 80% 90% 100%

Texture is important in expressing color.

It is difficult to give the appearance of color by simply applying a tone, and it is important to express the texture of the object drawn. First, have a firm grasp on a shape and draw it. Applying a tone and expressing color could be said to be supplementary.

What color is this??

Express color schemes in clothing through tones

When applying tones to human figures, it's important to match colors, just as with real fashion. Give it a try for a lively color scheme.

Assemble like color schemes

Offset the concentration a bit so the colors don't overlap.
Sand 40lpi 20%
Dots 60lpi 20%
Dots 42.5lpi 20%
Lines 42.5lpi 20%

Assemble light colors

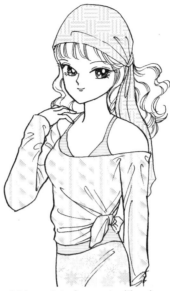

Add a point of accent, either in white or as a solid fill.
Wicker02
Lines 42.5lpi 5%
Alan02
Floral Pattern

Assemble deep colors

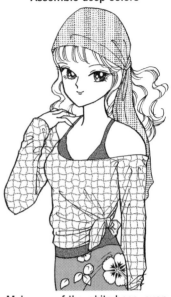

Make use of the white base, even if there is not much of it.
Rubber Weave
Sand 65lpi 20%
Sand 65lpi 50%
Coarse Hatching
Dot 60lpi 30%
Hibiscus02

Let's try using some other tones.

Denim style

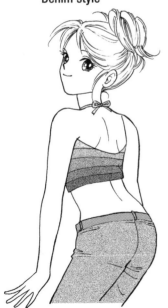

Use a sand tone on the denim fabric; keep the shirt on the inside slightly plain.
Sand 40lpi 20%
Sand 65lpi 20%
Sand 65lpi 30%
Sand 65lpi 40%
Sand 65lpi 50%

Patterned clothes

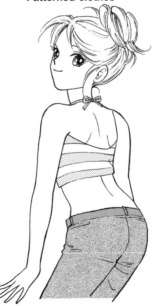

Patterns on both top and bottom do not go over well. Make the bottom a dot tone in an even, matching color.
Dot 42.5lpi 20%

Balance is important.
Except for certain distinctive uniforms, the same concentration on both upper and lower body clothing looks poor. Do either the top or the bottom in a darker matching color and make the image more attractive.

Fashion Tone Expressions: Girls

Try using a pattern tone to express clothing.

If you have characters, then you have to draw different clothing for them to wear. Pattern tones are convenient for this. By using pattern tones (tones that repeat a single image in a pattern), you can easily draw any patterned item, from a girl's dress to a man's necktie.

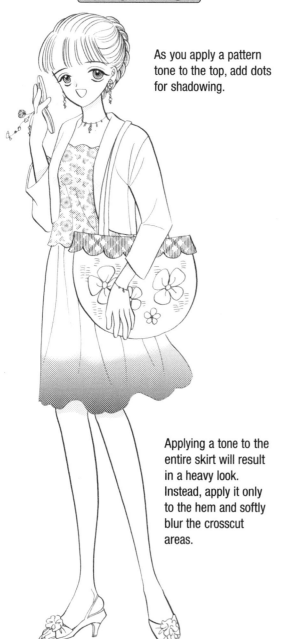

Spring clothing 1

As you apply a pattern tone to the top, add dots for shadowing.

Applying a tone to the entire skirt will result in a heavy look. Instead, apply it only to the hem and softly blur the crosscut areas.

Tops: wildflowers
Bag: fabric checker 01
Skirt: gradation tone 60 lpi 100-0-100

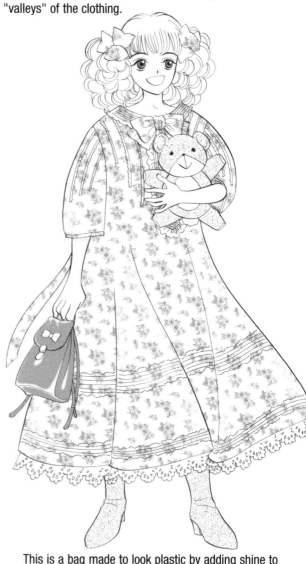

Spring clothing 2

This has been made into a one-piece outfit with a pattern tone application. The translucent effect was achieved by blurring the pattern in the "ridges" and "valleys" of the clothing.

This is a bag made to look plastic by adding shine to the corners and irregular surfaces.

One-piece and ribbon: Rose 03
Bag: Dots 60 lpi 30%
Boots and plushie: sand grain 5%

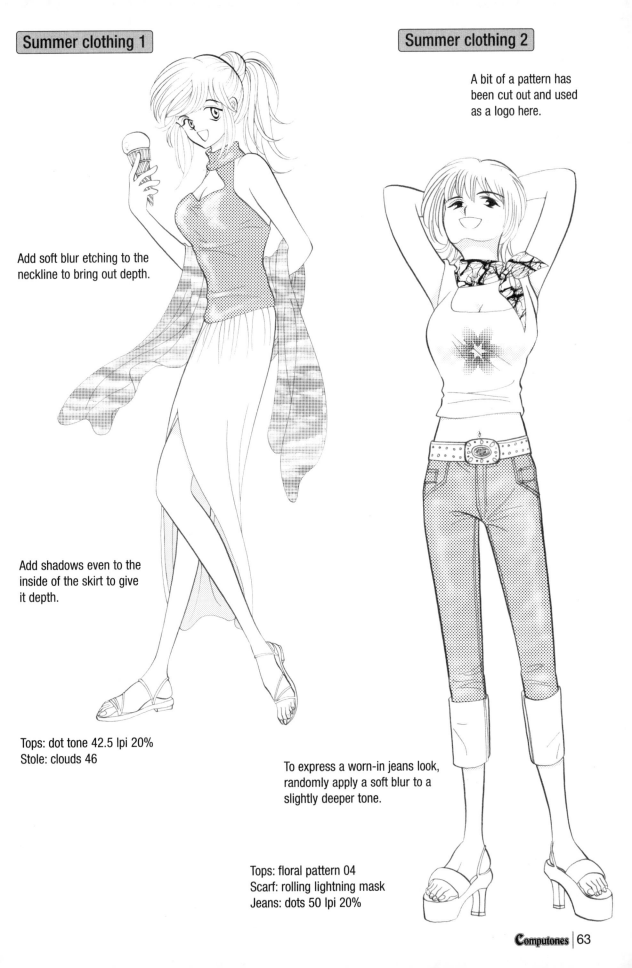

Summer clothing 1

Add soft blur etching to the neckline to bring out depth.

Add shadows even to the inside of the skirt to give it depth.

Tops: dot tone 42.5 lpi 20%
Stole: clouds 46

Summer clothing 2

A bit of a pattern has been cut out and used as a logo here.

To express a worn-in jeans look, randomly apply a soft blur to a slightly deeper tone.

Tops: floral pattern 04
Scarf: rolling lightning mask
Jeans: dots 50 lpi 20%

Autumn clothing 1

Autumn girls 2

For a knit cap made from slightly rough materials, use a rough sand tone.

To express a patterned skirt we used a pattern tone. Changing the tone's direction and angle would be fine, too.

There is a standard argyle pattern included as well. For a worn-in look, blur it just a little.

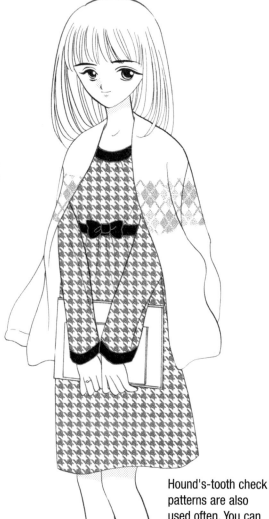

Hound's-tooth check patterns are also used often. You can use them to effect a classy look.

Hat: sand 45 lpi
Vest: wicker 01
Bag: dot tone 65 lpi 50%
Skirt: sand hatching radial gradation 20-0-20

One-piece: checker 06
Cardigan: checker 07

Winter clothing 1

Applying too many pattern tones to the whole image will make it look sloppy, so only the scarf and the back have been pulled together with a small pattern tone.

Winter clothing 2

We used a sand grain tone to express the texture of that rough hat earlier, but this time we used a cotton pattern. The look of the rough dots is what gives the fabric a soft expression.

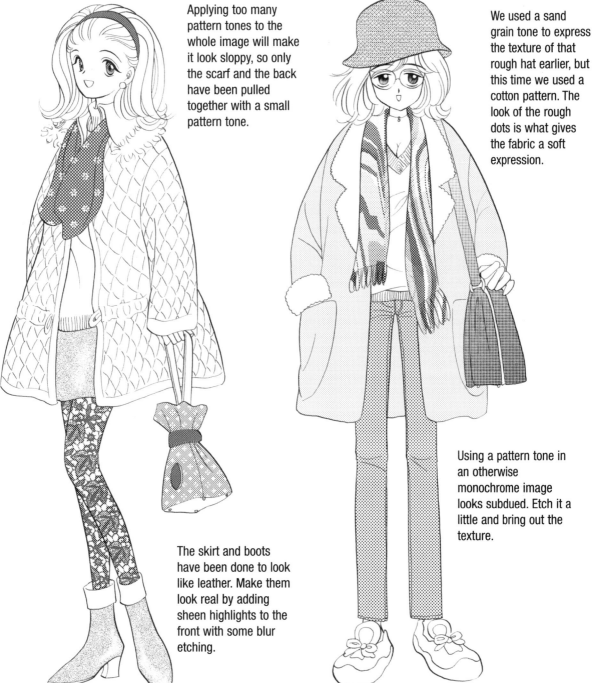

The skirt and boots have been done to look like leather. Make them look real by adding sheen highlights to the front with some blur etching.

Using a pattern tone in an otherwise monochrome image looks subdued. Etch it a little and bring out the texture.

Scarf: flower 02A
Tights: leaf-pattern lace
Hairband: dot tone 65 lpi 50%
Skirt and boots: sand 75 lpi 10%
Bag: monogram

Scarf: marble dots 01
Bag: gradation tone 60 lpi 100-0-100
Jeans: dot tone 42.5 lpi 20%
Hat: cotton lining

How to effect depth in pattern tones

Since just applying a tone as is can only look flat and uniform, use the Pen and add wrinkles. Add highlight etching and shadows to them, but if you etch too much then the balance of the tone will be destroyed. Be careful.

Fashion tone expressions: boys

Spring clothing 1

For a rough feeling, add shadows with slightly more than normal dot tones. Since this is a rough image it is key that you rough up the shadows as well.

The clothing itself will also appear larger and will have a baggier feeling. Draw wrinkle lines large, and add wide shadows for a flowing appearance.

T-shirt (outside): dot tone 20 lpi 10%
T-shirt (inside): dot tone 60 lpi 30%

Spring clothing 2

Using either a blur brush or an airbrush is effective for expressing worn areas of denim. Do not blur the whole thing, but rather just the areas around the knees for a realistic look.

The shoes appear to be sneakers. Do not etch in spots. It is good to etch boldly.

Scarf: rubber weave
Hooded parka: Camouflage 02
Jeans: Dots 50 lpi 20%

Summer clothing 1

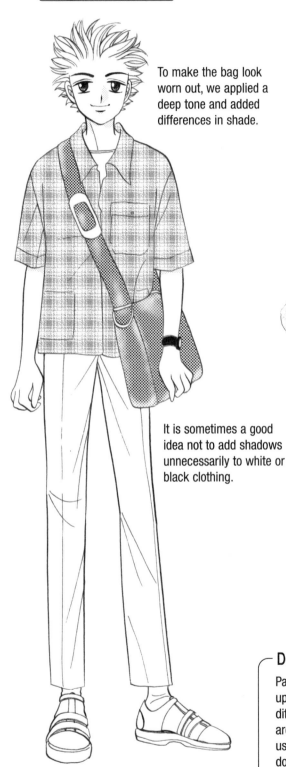

To make the bag look worn out, we applied a deep tone and added differences in shade.

It is sometimes a good idea not to add shadows unnecessarily to white or black clothing.

Shirt: checker 11
Bag: dot tone 50 lpi 40%

Summer clothing 2

We applied a dot tone here to express tanned, dark skin. This is how tones are used for this season.

For the fluffy, rough appearance of a towel, etch widely in the wrinkled areas.

Swimsuit: checker 14
Towel: floral pattern 01
Cell phone belt: dot tone 65 lpi 40%
Sunglasses, cell phone, and can: radial gradation 016
Skin: dot tone 65 lpi 5%

Do not apply the same pattern tones in succession.

Pattern tones are useful, but they stick out, and lining them up can make an image appear sloppy. It can also make it difficult to tell where the boundaries between different areas lie. Especially in indoor scenes, if the same pattern is used for a tablecloth and some wallpaper, for example, then do something like changing the size of one of the patterns and keep the two from stacking as much as possible.

Autumn clothing 1

For things like school uniforms or other clothing with uniform colors, you do not really need to do any etching. If there is some area you want to etch, then keep it to doing so around the outlines or on wrinkles.

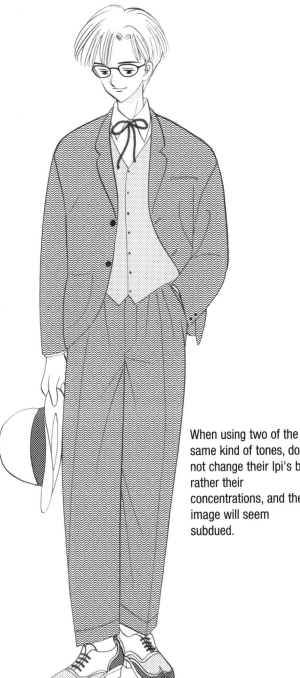

When using two of the same kind of tones, do not change their lpi's but rather their concentrations, and the image will seem subdued.

Suit: wavy lines 03
Shoes and hat: dot tone 55 lpi 50%
 dot tone 55 lpi 10%

Autumn clothing 2

We have unified this scene with the same simple, weak tone. The pattern on the jacket stands out, so the concentration has been toned down slightly.

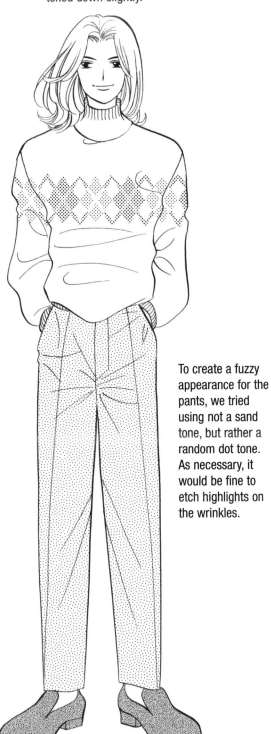

To create a fuzzy appearance for the pants, we tried using not a sand tone, but rather a random dot tone. As necessary, it would be fine to etch highlights on the wrinkles.

Sweater: checker 07
Pants: random dot
Shoes: sand 65 lpi 30%

Winter clothing 1

We used a tone with a unique texture for the fabric of this hat. The random, coarse texture works very well here.

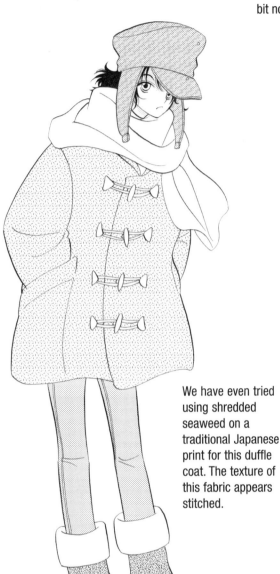

We have even tried using shredded seaweed on a traditional Japanese print for this duffle coat. The texture of this fabric appears stitched.

Coat: shredded seaweed 02
Boots: sand 45 lpi 20%
Jeans: dot tone 55 lpi 10%
Hat: twill 01c

Winter clothing 2

For a gorgeous look and a chic feel, we used a leopard print for the fabric on the back of this coat. It looks a bit nouveau riche, however.

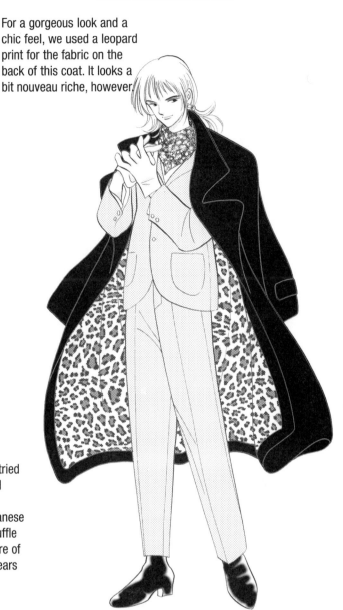

To bring out the texture of leather shoes, use blur etching. By making the blur area wide, you can make the shoes appear glossy.

Scarf: checker 13
Coat: leopard
Suit: dot tone 42.5 lpi 5%

How to produce sheen on precious metals

Precious metals are an indispensable item for females. Though it can depend on their type, normally you often use gradation tones, and show the unique shine of a precious metal by etching gradations.

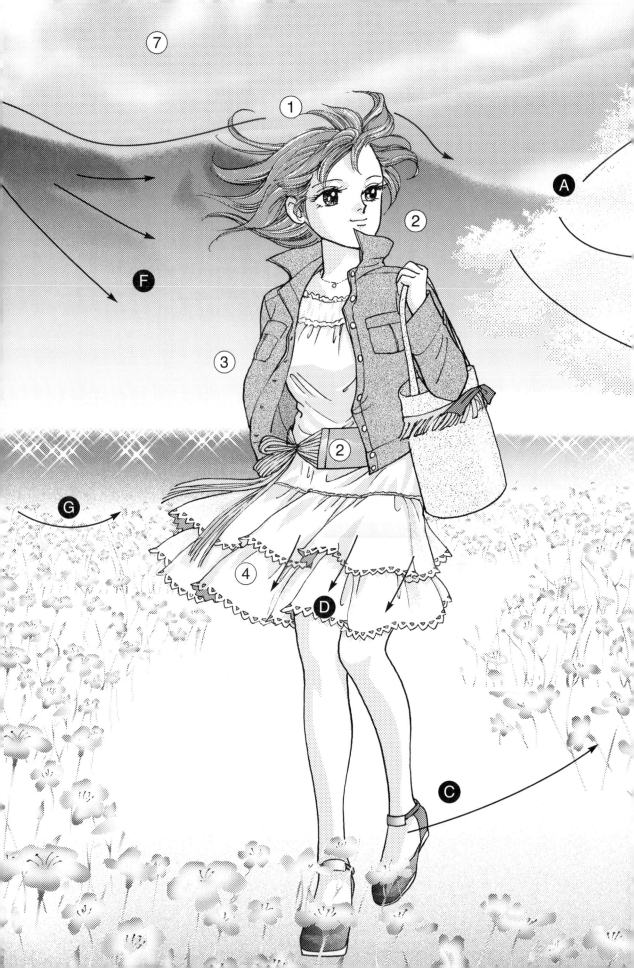

Scene Direction through Tones

Here, we introduce how to use tones as a theme for the four seasons not only for clothing, but also as part of a scene. Look for which tones are used where, and as we will explain the techniques used on the right, please be sure to give it a read.

Spring landscapes and characters

Tones and techniques used

1. Hair: Dot tone 60 lpi 30%
2. Skin: Dot tone 50 lpi 10%
3. Coat: Sand 65 lpi 20%
4. One-piece: Dot tone 60 lpi 10%
5. Belt: Dot tone 60 lpi 20%
6. Bag: Sand 40 lpi 5%
7. Sky: Clouds 06
8. Flowers: Floral dance 01
9. Cherry Blossoms: Dot tone 42.5 lpi 5%

How to etch with a brush

Ⓐ Cherry tree: Use a soft blurring brush along the clump of foliage.
Ⓑ Foot of a tree: Use a soft blurring brush at the lines between ground and roots.
Ⓒ Ground surface: Use a soft blurring brush at the lines between light and dark.
Ⓓ Skirt: Use a soft blurring brush along the shadow of pleats on a skirt.
Ⓔ Mountains: Use a soft blurring brush along the crest.
Ⓕ Mountains: Use a soft blurring brush along the base of mountains.
Ⓖ River: Use a soft blurring brush along the riverbank.

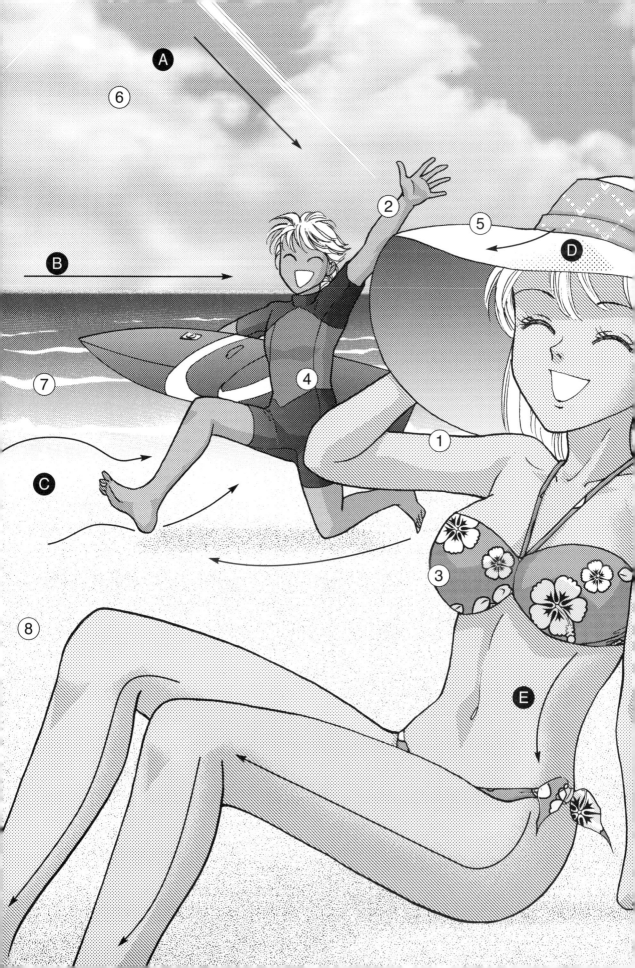

Summer landscapes and characters

Tones and techniques used

①Female skin: Dot tone 42.5 lpi 10%

②Male skin: Dot tone 60 lpi 20%

③Female swimsuit: Hibiscus 02

④Male swimsuit: Dot tone 60 lpi 30% / Gradation tone 60 lpi

⑤Hat: Quilted Heart / Gradation tone 60 lpi / Dot tone 27.5 lpi 10%

⑥Sky: Clouds 50

⑦Waves: Gradation tone 60 lpi

⑧Sand: Sand 40 lpi 5%

How to etch with a brush

Ⓐ Sunlight: Use a sharp brush to express blaze of the sun.

Ⓑ Sea line: Use a soft blurring brush on the waves.

Ⓒ Sandy beach: Use a soft blurring brush in spots to make the surface look rough.

Ⓓ Hat: Use a soft blurring brush at the edge of the shadow on the brim.

Ⓔ Body: Use a soft blurring brush at the edge of the shadow.

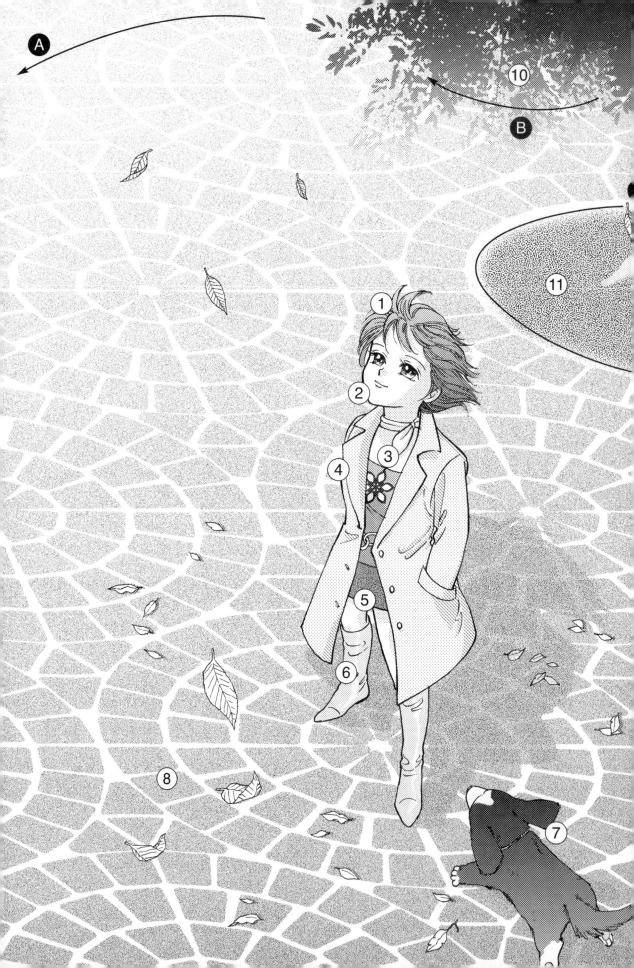

Autumn landscapes and characters

Tones and techniques used

1. Hair: Gradation tone 60 lpi
2. Skin: Dot tone 50 lpi 10%
3. Clothing: Dot tone 60 lpi 20%, Flower 02B
4. Coat: Dot tone 42.5 lpi 5%
5. Skirt: Sand 65 lpi 30%
6. Boots: Dot tone 60 lpi 10%
7. Dog: Gradation tone 60 lpi
8. Ground: Sand 65 lpi 10%
9. Tree: Dot tone 60 lpi 10%
10. Leaves: Gradation tone 60 lpi
11. Soil: Sand 40 lpi 30%

How to etch with a brush

A Ground surface: Use a soft blurring brush at the deepest part to express
B highlighting.
C Foliage: Use a soft blurring brush at the tip of the foliage.
D Tree trunk: Use a sharp brush along the roughness of a tree trunk.
E Soil under the tree: Use a soft blurring brush around the soil.

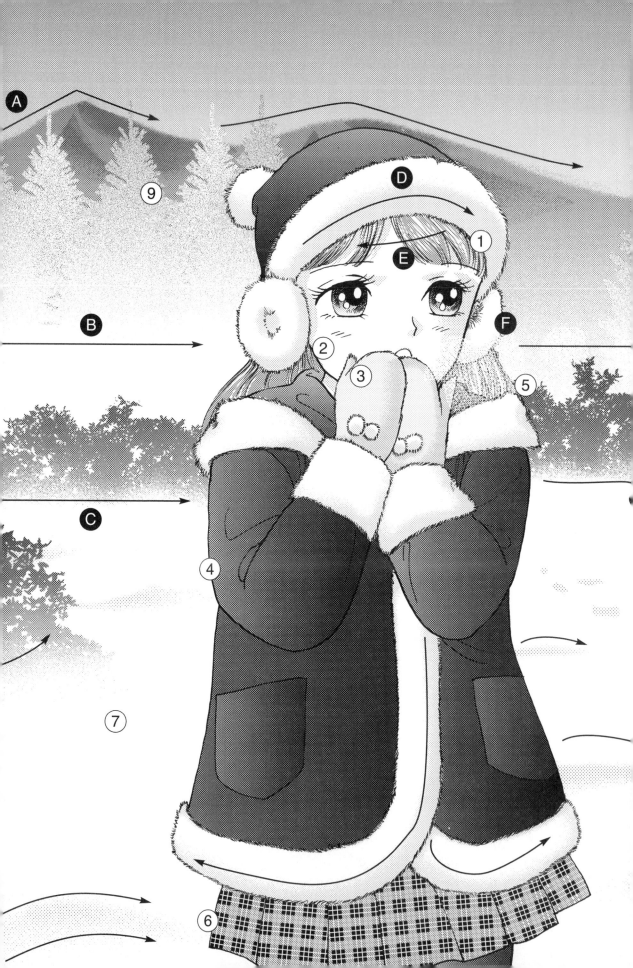

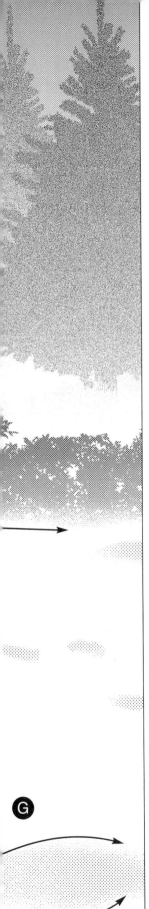

Winter landscapes and characters

Tones and techniques used

1. Hair: Dot tone 60 lpi 30%
2. Skin: Dot tone 50 lpi 10%
3. Gloves: Dot tone 60 lpi 5%
4. Clothing Shadows: Dot tone 50 lpi 10%
5. Breath: Hatching
6. Skirt: Checker 08
7. Snow: Dot tone 42.5 lpi 10%
8. Tree: Sand 65 lpi 30% / Sand 65 lpi 40%
9. Other: Gradation tone 60 lpi

How to etch with a brush

A Mountains: Use a soft blurring brush along the crest.

B Woods: Use a soft blurring brush below the clump of foliage.

C Bush: Use a soft blurring brush blow the clump of foliage.

D Fur: Use a blurring brush around the boundaries of irregular surfaces.

E Hair: Use a large blurring brush with light touch.

F Breath: Use a rough blurring brush in a circular motion to express white smoke in the cold air.

G Snow: Use a soft blurring brush in spots to make the surface look rough.

Computones Vol. 2 Installation
Quick Reference for Volume 1 Owners

In case you are unable to install the tone data files from a CD-ROM, please follow the instruction below.

From the main data and tone data files included with Vol. 2, Computones Vol. 1 owners should only install the tone data files. Please read and follow the instructions below.

Insert the included CD-ROM in your CD-ROM drive and display the tone data.

1) Once you have loaded the CD-ROM into your computer's CD-ROM drive and read the CD, open the Computones → CTHDM02 folder.

 Open the Computones folder on your computer and copy the tone data.

2) Copy the CTHDM02 folder you found earlier to wherever on your computer's hard disk the Vol. 1 data has been installed.

The steps...
 For Photoshop:
 Program Files → Adobe → Photoshop → Plugins → Computones

 For Photoshop Elements:
 Program Files → Adobe → Photoshop Elements → Plugins → Computones

 For Paint Shop PRO:
 Program Files → Jasc Software Inc → Paint Shop PRO → Plugins → Computones

 Create a new tone data folder.

Start your graphics application, start Computones, and click on the Menu button of the tone catalog in the upper right corner of your screen. Select "New Tone List" at the top of that menu. You will be asked to name your new list of registered tone resources. Give it any name you like.

Once again, click on the Menu button of the tone catalog in the upper right corner of your screen, and then select "New List." You will be asked where you wish to save your newly registered tone data. Select the tone resource folder inside your graphic application's Plug-in folder to complete the registration process.

Chapter 3

Manual

Chapter 1: Preliminaries

System Requirements

• Have installed at least one of the following:
Adobe Photoshop 5.0/5.5/6.0/7.0/CS or Adobe Photoshop LE 5.0; Adobe Photoshop Elements 1.0/2.0; Jasc Paint Shop Pro 7.0/8.0.

• Use one of the following operating systems:
Microsoft Windows 98 SE, Windows ME, Windows 2000, or Windows XP.

• Meet or exceed the following hardware specifications:
Intel Pentium or 100% compatible CPU (Pentium 3 800 MHz or higher recommended)
CD-ROM drive
128MB RAM or more (256MB or more recommended)
250MB or more of free local disk space (950MB or more recommended)

Adobe Photoshop Elements and Jasc Paint Shop Pro limit certain operations, and Computones' Autolayer functionality will not work with them. However, it is possible to manually create a new layer and lay it atop an image. For more details, consult the Software Functions Table on the next page. Further, there is no guarantee that this software will function perfectly with other Photoshop plug-in-compatible software packages that are not listed above.

1-2 Computones-Compatible Image File Formats
The image file formats Computones will and will not support are listed below.

Supported:
Grayscale
Duotone
RGB Color
CMYK Color
Lab Color

Not Supported:
Bitmap
Indexed Color
Multichannel
All 16 Bits/Channel modes

Chapter 2: Photoshop 5.0/5.5/6.0/7.0/CS

This chapter is for readers using Photoshop 5.0/5.5/6.0/7.0/CS.

Before You Install

These installation notes are for all supported operating systems (Microsoft Windows 98 SE, Windows Me, Windows 2000, or Windows XP).

- Make certain you have Photoshop 5.0, 5.5, 6.0, 7.0, or CS (hereafter "Photoshop") installed.

- Shut down any antivirus software or any other background applications, and adjust your operating system so that your machine does not go into sleep mode during installation.

- Having multiple graphics software packages installed on the same machine can interfere with the normal use of this software.

Installing Computones

"Computones" is made up of a tone plug-in and a Computones-specific data set made up of tones. Follow the installation steps below in order to use them.

Step 1

Insert the Computones CD-ROM into a CD-ROM drive.

Step 2

Double-click on the My Computer icon on the Windows desktop (Windows XP users should click on the Start Menu and then click on My Computer), and double-click on the Computones CD-ROM icon. The Computones Installer.exe (or simply "Computones Installer") icon will appear. Double-click on it to start the installation.

Step 3

You will be asked to which folder or directory you want to install Computones. Select "Install in the Photoshop Plug-Ins folder." The installer will then automatically search for the plug-ins folder and install Computones.

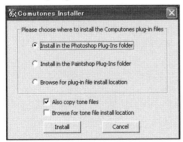

Step 4

Next, install the Computones-specific tone data set.

If "Also copy tone files" is checked, then the plug-in, tone data, and tone sets on the CD-ROM will be selected and written to the local disk.

If "Also copy tone files" is not checked, then Tone and other utility programs will be installed, but every time you use the plug-in, the tone data and sets on the CD-ROM will need to be read from it.

If "Browse for tone file install location" is checked together with "Also copy tone files," then you can choose to which folder you will install the tone files.

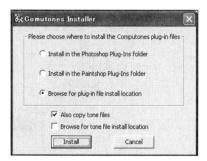

Step 5

When you click on the Install button, you will be prompted to confirm the install folder. If everything is OK, then click on the Yes button and the installation will begin. If there is a problem with the selected folder, then click on the No button. You will then have to check "Browse for tone file install location" and manually specify the install folder. When you have done so, click on the OK button.

• In the following cases, Computones will not be able to automatically search for an install folder, and so you must check "Browse for tone file install location" and then manually specify the install folder. This will also be necessary if the error message shown here should appear at any other point.

1) The Photoshop Plug-Ins folder has somehow been changed.
 The installer will only search for the Plug-Ins folder inside the Photoshop install folder. In any other case, manually specify the install location.

2) There is more than one graphics software package installation.
 The installer will automatically search for the Photoshop install folder. If the folder it finds is not what you normally use, then manually specify the install folder for you do normally use for Photoshop.

3) The automatic search may fail for reasons not covered by the above. In such cases, manually specify the Photoshop folder.

Step 6

When you have confirmed the install folder and hit the OK button, if you have checked "Also copy tone files," then a dialog box titled, "Select installation files" will appear. This box will not appear if you have not checked this option, and you may proceed to Step 8. The list on the left side of the window will show the tone file groups present on the CD-ROM, while the list on the right shows the tone file groups to be installed. If there is some tone file group in the list on the right that you will not be using, select it from the list and hit the Remove button. When all the file groups you want have been added, click on the OK button.

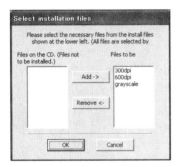

Step 7

If you have checked "Browse for tone file install location" and begun the installation, then you can choose where you wish to create the folder that will hold all the tone files. A dialog box will appear asking you about this; at that point, specify the folder as you wish. If you have not checked "Browse for tone file install location," then a tone file install folder will automatically be created within the plug-in install folder, and no dialog box will appear.

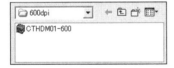

Step 8

Once the installation begins, a progress bar will be displayed. The installation may take some time, so if you are using a computer with a battery, please make sure you are also using an AC adapter when you install Computones. Hitting the Cancel button will stop the installation, and tone files in mid-installation will automatically be deleted. Once the installation is complete, a window will appear indicating so. Click on the OK button.

Step 9

After the installation is complete, launch Photoshop. If you select File → New... and create a new file, "Computones" will be displayed in the Filter menu. From there you can start using tones.

*If "Computones" is not displayed in the Filter menu, then it is possible that the folder in which the Plug-Ins reside and the plug-in install folder are different. You can check the location of the Plug-Ins folder at Edit → Preferences in Photoshop 6.0/7.0/CS (File → Preferences in Photoshop 5.0/5.5) under "Plug-Ins and Scratch Disks..."

Step 10

Once you have launched Photoshop, open the "Companion.psd" file located in the Sample folder on the Computones CD-ROM. Open the Filter menu and start up Computones. Immediately after startup, you will be asked just once for a serial number. Enter the serial number at the first of this book and click on OK.

Step 11

Installation is now complete.

Try Using Some Tones
Let's get started right away!

Step 1

Start Photoshop, access Edit → Preferences in Photoshop 6.0/7.0 (Files → Preferences in Photoshop 5.0/5.5), and select "General..." A new window will open, and in that window is an Interpolation pull down menu. Select "Nearest Neighbor (fastest)" in that menu and click on OK.

Step 2

Select File → Open...and an Open window will appear so you can select a file to read in. Open the Companion.psd file in the Sample folder on the Computones CD-ROM.

Step 3

Adjust the resolution of the sample image you opened in Step 2. Adjust it to match the resolution of the printer you are using such that one is an integral multiple of the other. For example, if you are using a printer capable of printing 720 dpi images, set your image resolution to be 360 or 720 dpi. If the horizontal and vertical printer resolutions are different (for example, 1440 x 720 dpi), then your image resolution should be a multiple of one or the other. In theory, a 1440 dpi resolution would be usable, but from a quality perspective it is too high. A lower setting is better.

To change the image resolution in Photoshop, click on Image → Image Size... A window will pop up; input a new value where the "600" is displayed in the Resolution field. Keep in mind the units are in pixels/inch.

- If you don't know the output capabilities of your printer, it does not matter if you leave the setting (600 dpi) as is, but printed copies of your image may look blurry as a result.

Step 4

Use Photoshop's Magic Wand Tool to select the collar area of the clothing on the figure in your sample image. We will call this selected portion the "Tone Draw Area." Now set the Magic Wand Tool's Tolerance value to 1, and uncheck Anti-aliased.

- Please consult your Photoshop manual for more on the Magic Wand and its option bar. Using tones without specifying a Tone Draw Area will automatically make the entire image the effective Tone Draw Area.

Step 5

Select Filter → Computones → Tone...

- If "Computones" does not appear in the Filter menu, please go back to the "Installing Computones" section and review the installation process.

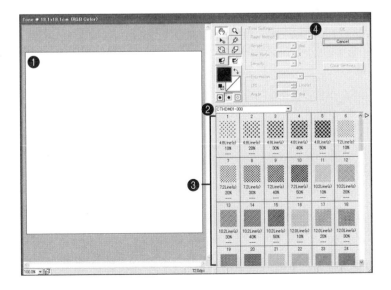

Step 6

In the middle of your screen, a Computones window will appear. At the left side of that window, there is a "Preview Display," and in it part of the image will be displayed at a 100% display ratio.❶

Step 7

Click on the Tone Set Selection pull-down menu and select the "CTHDM01-600" tone set. The contents of the tone set are displayed at the bottom right in the Tone Set Area.❷

• If you did not check the "Also copy tone files" box at installation, then every time you use tones they will be read directly from the Computones CD-ROM. Therefore, when you are using Computones you must make sure the CD-ROM is in the CD-ROM drive at all times.

Step 8

Try clicking on a tone you like from the Tone Set Area. We recommend you try out the "50.0 Line(s) 10%" dot tone. (If you don't see an exact match, choose a tone with similar values.)❸

Step 9

Click on a tone, and it will cover the Tone Draw Area you specified in Step 4. If you would like to change tones, just click on another tone in the Tone Set Area.

• If you'd like to specify a different Tone Draw Area, then you have to go back to Photoshop first, and execute this process from Step 4 again.

Step 10

If you would like to apply the effects you have created to the sample image, then hit the OK button. After the tone you have selected has been applied, you will go back to Photoshop. If you print out your work, you can see the real results in more minute detail.

If you would rather not apply the effects you have created to the sample image, then click on the Cancel button. The sample image will be unchanged, and you will return to Photoshop.❹

Chapter 3: Photoshop Elements 1.0/2.0

This chapter is for readers using Photoshop Elements 1.0/2.0.

Before You Install

These installation notes are for all supported operating systems (Microsoft Windows 98 SE, Windows Me, Windows 2000, or Windows XP).

- Make certain you have Photoshop Elements 1.0/2/0 (hereafter "Elements") installed.

- Shut down any antivirus software or any other background applications, and adjust your operating system so that your machine does not go into sleep mode during installation.

- Having multiple graphics software packages installed on the same machine can interfere with the normal use of this software.

Installing Computones

"Computones" is made up of a tone plug-in and a Computones-specific data set made up of tones. Follow the installation steps below in order to use them.

Step 1

Insert the Computones CD-ROM into a CD-ROM drive.

Step 2

Double-click on the My Computer icon on the Windows desktop (Windows XP users should click on the Start Menu and then click on My Computer), and double-click on the Computones CD-ROM icon. The Computones Installer.exe (or simply "Computones Installer") icon will appear. Double-click on it to start the installation.

Step 3

You will be asked to which folder or directory you want to install Computones. Select "Install in the Photoshop Plug-Ins folder." The installer will then automatically search for the Photoshop Elements plug-ins folder and install Computones.

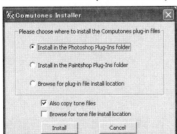 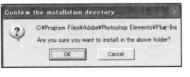

Step 4

Next, install the Computones-specific tone data set.

If "Also copy tone files" is checked, then the plug-in, tone data, and tone sets on the CD-ROM will be selected and written to the local disk.

If "Also copy tone files" is not checked, then Tone and other utility programs will be installed, but every time you use the tone data and sets on the CD-ROM they will need to be read from it.

If "Browse for tone file install location" is checked together with "Also copy tone files," then you can choose to which folder you will install the tone files.

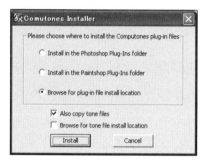

Step 5

When you click on the Install button, you will be prompted to confirm the install folder. If everything is OK, then click on the Yes button and the installation will begin. If there is a problem with the selected folder, then click on the No button. You will have to check "Browse for tone file install location" and then manually specify the install folder. When you have done so, click on the OK button.

• In the following cases, Computones will not be able to automatically search for an install folder, and so you must check "Browse for tone file install location" and then manually specify the install folder. This will also be necessary if any of the error messages shown here should appear at any other point.

1) The Photoshop Elements Plug-Ins folder has somehow been changed.
 The installer will only search for the Plug-Ins folder inside the Photoshop Elements install folder. In any other case, manually specify the install location.

2) There is more than one graphics software package installation.
 The installer will automatically search for the Photoshop Elements install folder. If the folder it finds is not what you normally use, then manually specify the install folder you do normally use for Photoshop Elements.

3) The automatic search may fail for reasons not covered by the above. In such cases, manually specify the Photoshop Elements folder.

Step 6

When you have confirmed the install folder and hit the OK button, if you have checked "Also copy tone files," then a dialog box titled, "Select installation files" will appear. This box will not appear if you have not checked this option, and you may proceed to Step 8. The list on the left side of the window will show the tone file groups present on the CD-ROM, while the list on the right shows the tone file groups to be installed. If there is some tone file group in the list on the right that you will not be using, select it from the list and hit the Remove button. When all the file groups you want have been added, click on the OK button.

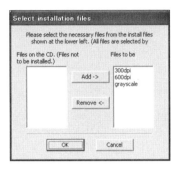

Step 7

Ilf you have checked "Browse for tone file install location" and begun the installation, then you can choose where you wish to create the folder that will hold all the tone files. A dialog box will appear asking you about this; at that point, specify the folder as you wish. If you have not checked "Browse for tone file install location," then a tone file install folder will automatically be created within the plug-in install folder, and no dialog box will appear.

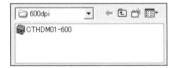

Step 8

Once the installation begins, a progress bar will be displayed. The installation may take some time, so if you are using a computer with a battery, please make sure you are also using an AC adapter when you install Computones. Hitting the Cancel button will stop the installation, and tone files in mid-installation will automatically be deleted. Once the installation is complete, a window will appear indicating so. Click on the OK button.

Step 9

After the installation is complete, launch Photoshop Elements. If you select File →
New... and create a new file, "Computones" will be displayed in the Filter menu. From
there you can start using tones.

If "Computones" is not displayed in the Filter menu, then it is possible that the folder
in which the Plug-Ins reside and the plug-in install folder are different. You can check
the location of the Plug-Ins folder at Edit → Preferences under "Plug-Ins and Scratch
Disks..."

Step 10

Once you have launched Photoshop Elements, open the "Companion.psd" file located
in the Sample folder on the Computones CD-ROM. Open the Filter menu and start up
Computones. Immediately after startup, you will be asked just once for a serial
number. Enter the serial number at the first of this book and click on OK.

Step 11

Installation is now complete.

Try Using Some Tones
Let's get started right away!

Step 1
Start Photoshop Elements, select File → Open... and an Open window will appear so you can select a file to read in. Open the Companion.psd file in the Sample folder on the Computones CD-ROM.

- If you are unsure how to use File → Open..., please consult the Photoshop Elements manual.

Step 2
Adjust the resolution of the sample image you opened in Step 1. Adjust it to match the resolution of the printer you are using such that one is an integral multiple of the other. For example, if you are using a printer capable of printing 720 dpi images, set your image resolution to be 360 or 720 dpi. If the horizontal and vertical printer resolutions are different (for example, 1440 x 720 dpi), then your image resolution should be a multiple of one or the other. In theory, a 1440 dpi resolution would be usable, but from a quality perspective it is too high. A lower setting is better.

To change the image resolution in Photoshop Elements, click on Image → Image Size... A window will pop up; input a new value where the "600" is displayed in the Resolution field. Keep in mind the units are in pixels/inch, and in the lower part of the same window, "Resample Image" is set to "Nearest Neighbor."

- If you don't know the output capabilities of your printer, it does not matter if you leave the setting (600 dpi) as is, but printed copies of your image may look blurry as a result.

Step 3
Use Photoshop Elements' Magic Wand Tool to select the collar area of the clothing on the figure in your sample image. We will call this selected portion the "Tone Draw Area." Now set the Magic Wand Tool's Tolerance value to 1, and uncheck Anti-aliased.

- Please consult your Photoshop Elements manual for more on the Magic Wand and its option bar. Using tones without specifying a Tone Draw Area will automatically make the entire image the effective Tone Draw Area.

Step 4

Select Filter → Computones → Tone...

*If "Computones" does not appear in the Filter menu, please go back to the "Installing Computones" section and review the installation process.

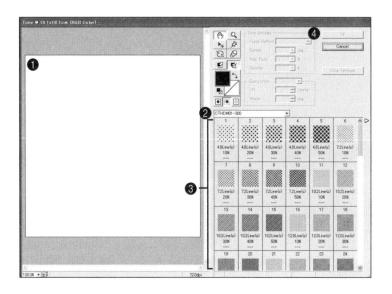

Step 5

In the middle of your screen, a Computones window will appear. At the left side of that window, there is a "Preview Display," and in it part of the image will be displayed at a 100% display ratio.❶

Step 6

Click on the Tone Set Selection pull-down menu and select the "CTHDM01-600" tone set. The contents of the tone set are displayed at the bottom right in the Tone Set Area.❷

*If you did not check the "Also copy tone files" box at installation, then every time you use tones they will be read directly from the Computones CD-ROM. Therefore, when you are using Computones you must make sure the CD-ROM is in the CD-ROM drive at all times.

Step 7

Try clicking on a tone you like from the Tone Set Area. We recommend you try out the "55.0 Line(s) 40%" dot tone. (If you don't see an exact match, choose a tone with similar values.)❸

Step 8

Click on a tone, and it will cover the Tone Draw Area you specified in Step 3. If you would like to change tones, just click on another tone in the Tone Set Area.

• If you'd like to specify a different Tone Draw Area, then you have to go back to Photoshop Elements first, and execute this process from Step 3 again.

Step 9

If you would like to apply the effects you have created to the sample image, then hit the OK button. After the tone you have selected has been applied, you will go back to Photoshop Elements. If you print out your work, you can see the real results in more minute detail.❹

If you would rather not apply the effects you have created to the sample image, then click on the Cancel button. The sample image will be unchanged, and you will return to Photoshop Elements.

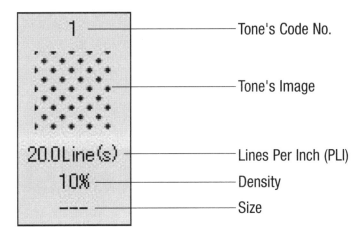

Tone's Code No.

Tone's Image

Lines Per Inch (PLI)

Density

Size

Chapter 4: Jasc Paint Shop Pro 7.0/8.0

This chapter is for readers using Jasc Paint Shop Pro 7.0/8.0.

Before You Install

These installation notes are for all supported operating systems (Microsoft Windows 98 SE, Windows Me, Windows 2000, or Windows XP).

• Make certain you have Jasc Paint Shop Pro 7.0/8.0 (hereafter "Paint Shop Pro") installed.

• Shut down any antivirus software or any other background applications, and adjust your operating system so that your machine does not go into sleep mode during installation.

• Having multiple graphics software packages installed on the same machine can interfere with the normal use of this software.

Installing Computones

"Computones" is made up of a tone plug-in and a Computones-specific data set made up of tones. Follow the installation steps below in order to use them.

Step 1

Insert the Computones CD-ROM into a CD-ROM drive.

Step 2

Double-click on the My Computer icon on the Windows desktop (Windows XP users should click on the Start Menu and then click on My Computer), and double-click on the Computones CD-ROM icon. The Computones Installer.exe (or simply "Computones Installer") icon will appear. Double-click on it to start the installation.

Step 3

You will be asked to which folder or directory you want to install Computones. Select "Install in the Paint Shop Pro Plug-Ins folder." The installer will then automatically search for the Paint Shop Pro plug-ins folder and install Computones.

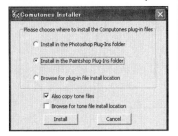

Step 4

Next, install the Computones-specific tone data set.

If "Also copy tone files" is checked, then the plug-in, tone data, and tone sets on the CD-ROM will be selected and written to the local disk.

If "Also copy tone files" is not checked, then Tone and other utility programs will be installed, but every time you use the plug-in, the tone data and sets on the CD-ROM will need to be read from it.

If "Browse for tone file install location" is checked together with "Also copy tone files," then you can choose to which folder you will install the tone files.

Step 5

When you click on Install, the installer will ask you to select the folder designated for Paint Shop Pro Plug-Ins if there are multiple folders present. If there is only one folder designated as such, then hit the OK button and the installation will begin. If there is some kind of problem with the install folder, then you will have to hit the No button, check the "Browse for tone file install location" box, and specify the folder manually. When you are done, hit the OK button.

Step 6

When you have confirmed the install folder and hit the OK button, if you have checked "Also copy tone files," then a dialog box titled, "Select installation files" will appear. This box will not appear if you have not checked this option, and you may proceed to Step 8. The list on the left side of the window will show the tone file groups present on the CD-ROM, while the list on the right shows the tone file groups to be installed. If there is some tone file group in the list on the right that you will not be using, select it from the list and hit the Remove button. When all the file groups you want have been added, click on the OK button.

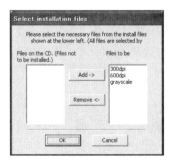

Step 7

IIf you have checked "Browse for tone file install location" and begun the installation, then you can choose where you wish to create the folder that will hold all the tone files. A dialog box will appear asking you about this; at that point, specify the folder as you wish. If you have not checked "Browse for tone file install location," then a tone file install folder will automatically be created within the plug-in install folder, and no dialog box will appear.

Step 8

Once the installation begins, a progress bar will be displayed. The installation may take some time, so if you are using a computer with a battery, please make sure you are also using an AC adapter when you install Computones. Hitting the Cancel button will stop the installation, and tone files in mid-installation will automatically be deleted. Once the installation is complete, a window will appear indicating so. Click on the OK button.

Step 9

After the installation is complete, launch Paint Shop Pro. If you select File → New... and create a new file, "Computones" will be displayed in the Filter menu. From there you can start using tones.

If "Computones" is not displayed in the Filter menu, then it is possible that the folder in which the Plug-Ins reside and the plug-in install folder are different. You can check the location of the Plug-Ins folder at Edit → Preferences under "Plug-Ins and Scratch Disks..."

Step 10

Once you have launched Paint Shop Pro, open the "Companion.psd" file located in the Sample folder on the Computones CD-ROM. Open the Filter menu and start up Computones. Immediately after startup, you will be asked just once for a serial number. Enter the serial number at the first of this book and click on OK.

Try Using Some Tones
Let's get started right away!

Step 1
Start Paint Shop Pro, select File → Open... and an Open window will appear so you can select a file to read in. Open the Companion.psd file in the Sample folder on the Computones CD-ROM.

- If you are unsure how to use File → Open..., please consult the Paint Shop Pro manual.

Step 2
Adjust the resolution of the sample image you opened in Step 1. Adjust it to match the resolution of the printer you are using such that one is an integral multiple of the other. For example, if you are using a printer capable of printing 720 dpi images, set your image resolution to be 360 or 720 dpi. If the horizontal and vertical printer resolutions are different (for example, 1440 x 720 dpi), then your image resolution should be a multiple of one or the other. In theory, a 1440 dpi resolution would be usable, but from a quality perspective it is too high. A lower setting is better.

To change the image resolution in Paint Shop Pro, click on Image → Resize... A window will pop up; check "Actual/print size" and input a new value where the "600.000" is displayed in the Resolution field. Keep in mind the units are in pixels/inch, and in the lower part of the same window, "Resize type" is set to "Pixel Resize."

- If you don't know the output capabilities of your printer, it does not matter if you leave the setting (600 dpi) as is, but printed copies of your image may look blurry as a result.

Step 3
After you click on the Magic Wand in the Tool palette, set the options in the Tool Options palette as follows:

1) Set the Match Mode to "RGB Value."
2) Set the Tolerance to 1.
3) Set Feather to 0.

- Please consult your Paint Shop Pro manual for more on the Magic Wand and its Tool Option palette.

Step 4

Use Photoshop Elements' Magic Wand Tool to select the collar area of the clothes on the figure in your sample image. We will call this selected portion the "Tone Draw Area."

*Using tones without specifying a Tone Draw Area will automatically make the entire image the effective Tone Draw Area.

Step 5

Select Effects → Plugin Filter → Computones → Tone...

*If "Computones" does not appear in the Plugin Filter menu, please go back to the "Installing Computones" section and review the installation process.

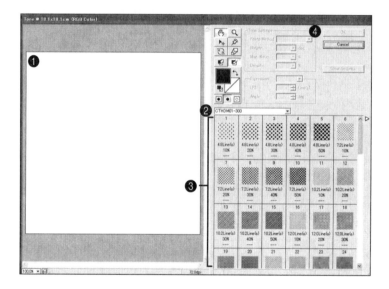

Step 6

In the middle of your screen, a Computones window will appear. At the left side of that window, there is a "Preview Display," and in it part of the image will be displayed at a 100% display ratio.❶

Step 7

Click on the Tone Set Selection pull-down menu and select the "CTHDM01-600" tone set. The contents of the tone set are displayed at the bottom right in the Tone Set Area.❷

*If you did not check the "Also copy tone files" box at installation, then every time you use tones they will be read directly from the Computones CD-ROM. Therefore, when you are using Computones you must make sure the CD-ROM is in the CD-ROM drive at all times.

Step 8

Try clicking on a tone you like from the Tone Set Area. We recommend you try out the "55.0 Line(s) 40%" dot tone. ❸

Step 9

Click on a tone, and it will cover the Tone Draw Area you specified in Step 4. If you would like to change tones, just click on another tone in the Tone Set Area.

• If you'd like to specify a different Tone Draw Area, then you have to go back to Paint Shop Pro first, and execute this process from Step 4 again.

Step 10

If you would like to apply the effects you have created to the sample image, then hit the OK button. After the tone you have selected has been applied, you will go back to Paint Shop Pro. If you print out your work, you can see the real results in more minute detail. ❹

If you would rather not apply the effects you have created to the sample image, then click on the Cancel button. The sample image will be unchanged, and you will return to Paint Shop Pro.

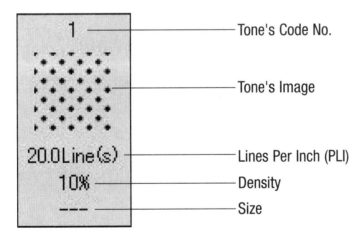

Tone's Code No.

Tone's Image

Lines Per Inch (PLI)

Density

Size

Uninstallation

Follow the steps below to uninstall Computones and completely remove it from your local disk.

Step 1
Insert the Computones CD-ROM into a CD-ROM drive.

Step 2
Double-click on the My Computer icon on the Windows desktop (Windows XP users should click on the Start Menu and then click on My Computer), and double-click on the Computones CD-ROM icon. The Computones Uninstaller.exe (or simply "Computones Uninstaller") icon will appear. Double-click on it to start the uninstallation.

Step 3
Next, a dialog box will appear. Choose an uninstallation method and hit the OK button.

"Remove only the plug-in folder"
This option removes the Computones plug-in itself only. The installed tone files stay as they are.

"Remove only the tone folders"
This option completely removes all the installed tone files. The plug-in file will remain, so the Computones plug-in will still be usable.

"Remove both the plug-in and tone folders"
This option completely removes all the installed plug-in and tone files.

Step 4
After starting the uninstaller, all the data covered by the option selected in Step 3 will be removed.

• If you install Computones more than once without uninstalling it, then only the most recently installed plug-in and/or tone files will be removed.

Step 5
If the uninstallation process completes normally, a message indicating so will appear. Hit the OK button.

• If the Computones installer was not used to install Computones, then an error message will appear. The same error will occur if you attempt to remove the tone folder when it does not exist on the local disk. In order to use the uninstaller, the Computones installer must have been used in the first place.

Chapter 5: Computones Functionality Overview

Tone Functions

The area selected via your graphic software determines the area in an image where a tone will be applied. If no such selection is made, then the tone will be applied to the entire image. For normal use, it is recommended that you first use your graphic software to select where in the image the tone is to be applied.

If your screen appears pink, it means that part of your image has been specified as a tone draw area. The actual draw area is the portion not shown in pink, but in white or gray.

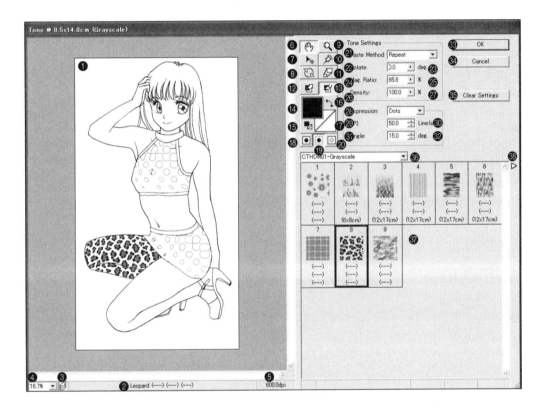

1) Preview Display
You can use this display to see how your image would look with a tone applied. You can use the scroll bars at the right and bottom of the display to scroll through the preview.

2) Selected Tone Info Area
The name, lines per inch (LPI), density, size, and other information on the tone currently applied to the Tone Draw Area are shown here. However, if the tone window is narrow, then all the information might not be displayed. Widening the window will reveal everything.

3) Preview Display Mode button

By turning this button on or off, you can display only the selected area ("Off") or you can display all possible layers, one on top of the other ("On").

• This function is not available in Paint Shop Pro.

4) Preview Display Ratio

Much like the Zoom Tool, clicking on this pull-down menu and then choosing one of the 13 choices inside it changes the display ratio of the image in the preview display. The choices are spread over 13 different steps between 5% and 800%, so you can zoom in or out on your image.

5) Image Resolution

This constant display shows the resolution of your image in dots per inch (DPI).

6) Hand Tool button

Clicking this button will start the Hand Tool, and the cursor will take the shape of a hand. You can use the hand tool to move the image around in the preview display. You can do the same thing with the scroll bars; however, they cannot move pins or applied tones separately.

7) Move Tool button

Hitting this button brings up the Move Tool, and the cursor will change into an arrowhead with four-way arrow. Using it in the preview display allows you to move a pin or an applied tone without moving the image itself.

8) Rotate Tool button

Clicking this button starts the Rotate Tool, and the cursor will change into a curly double arrow. Clicking and dragging on an image with this tool will rotate an applied tone around a pin.

9) Zoom Tool button

Hitting this button brings up the Zoom Tool, and turns your cursor into magnifying glass. You can use this tool to zoom in or out on the preview display over 13 steps, from 5% to 800%. Clicking on the preview display with the Zoom Tool icon as is will zoom in, while holding down the Alt key and clicking on it will zoom out.

10) Pin Tool button

Clicking on this button starts the Pin Tool, turning the cursor into a pin. The Pin Tool "pins" a tone down to a location of your choosing, and then serves as an axis around which you can rotate a tone. You can move the pin by clicking on the preview display; its default location is in the upper right corner of the image.

11) Scale Tool button

Hit this button to bring up the Scale Tool, and the cursor will turn into a double-ended arrow. You can then change the dimensions of an applied tone in all directions (centered on a pin) while maintaining the same image aspect ratio. Also, the magnification factor is indicated in a separate field; you can change this factor by directly entering a different value.

12) Use Host Color button

Hitting this button sets the foreground color to whatever color you are using in Photoshop or another host application, and renders the background transparent. If your Image Mode is set to Render Foreground and Background Colors, then the foreground color is set to transparent, and the background color will be set to whatever color you are using in your host application.

13) Use Custom Color button

If your Image Mode is set to Render Foreground and Background Colors when you press this button, then the foreground color will be rendered in 100% black, and the background color will be set to 100% white. If the Image Mode is set to Render in Foreground Color, then the foreground color will be set to transparent, and the background to 100% white.

14) Foreground Color Selection box

Clicking on this box will start up the Color Picker, and you can use it to change the foreground color. By doing so, you can also change the color of the tone you will be applying. The default foreground color is 100% black. If your Image Mode is set to Render in Foreground Color, the default is set to transparent.

- If you are unfamiliar with the usage of the Color Picker, please refer to your graphic software manual.

15) Restore Default Foreground and Background Colors icon

Clicking this icon sets the foreground color to 100% black and the background color to transparent. If you set the foreground or background colors to anything except 100% black, 100% white, or transparent, this icon will turn into a caution symbol.

16) Swap Foreground and Background Colors icon

Clicking this icon switches the foreground and background colors. You can produce black and white inversion effects this way.

17) Set Background Color box

Clicking on this box will open the Color Picker, and you can use it to change the background color. The default background color is transparent, but if your Image Mode is set to Render Foreground and Background Colors or Render in Background Color, the default is set to 100% white.

- If you are unfamiliar with the usage of the Color Picker, please refer to your graphic software manual.

18) Render Foreground and Background Colors button

Hitting this button will set the Image Mode to "Render Foreground and Background Colors." In Render Foreground and Background Colors mode, it is possible to color both the foreground and background. Each time you start using Tone, the foreground and background color settings will be as you left them the previous time.

19) Render in Background Color button

Hitting this button sets the Image Mode to Render in Background Color. In this mode the background color is set to transparent.

20) Render in Foreground Color button

Hitting this button sets the Image Mode to Render in Foreground Color. In this mode the foreground color appears transparent and is not visible.

21) Paste Method selection

You can choose how you apply a tone by choosing among the selections in this pull-down menu. For dot, line, and sand duotones, you can choose repeat or flip repeat. For radiating line and pattern duotones and grayscales, you can choose flip, flip repeat, don't repeat, no-flip repeat, and fold over.

22) Rotate field

Input a value in this field to rotate a tone as you wish. You can input any value from -360 degrees to 360 degrees in increments of 0.1 degrees. Inputting a value greater than 360 will result in the difference between that value and 360 being input. To enter the value after you input it, hit the Enter key or click anywhere on the tone. Hitting the Enter key twice will close the Tone window, so be careful.

23) Rotate Slide

You can also set a rotation angle by dragging the Angle Slide. The slide can move from -358 degrees to 358 degrees, in two-degree increments. The center, extreme left, and extreme right of the slide bar are set to zero degrees.

24) Magnification Ratio field

Entering a value in this field sets the magnification factor of your display. You can enter any value from 10% to 1000% in increments of 0.1%. To enter the value after you input it, hit the Enter key or click anywhere on the tone. Hitting the Enter key twice will close the Tone window, so be careful.

25) Magnification Ratio Slide

You can also set a magnification ratio by dragging the Magnification Ratio Slide. The slide can move from 10% magnification to 1000%, in 0.1% increments. The center of the slide bar is set to 100%. If you have specified a Tone Draw Area, then when you drag this slide the area will turn either white or gray, and the rest of the image will turn pink. To close the Magnification Ratio Slide, click anywhere outside the slide.

26) Density field

This field is only for grayscale tones. Entering a value in this field sets the density of a tone. You can enter any value from 20% to 180% in increments of 0.1%. To enter the value after you input it, hit the Enter key or click anywhere on the tone. Hitting the Enter key twice will close the Tone window, so be careful.

27) Density Slide

This field is only for grayscale tones. You can also set the density by dragging the Density Slide. The slide can move from 20% density to 180%, in 0.5% increments. The center of the slide bar is set to 100%. To close the Density Slide, click anywhere outside the slide.

28) Expression field

This field is only for grayscale tones. The choices of expression are None, Dots, Line, Cross, and Random. Choosing "None" will apply no dot shading.

29) LPI field

This field is only for grayscale tones; enter a lines per inch (LPI) value here as you like to apply dot shading. You can enter values from 1 to 85 in 0.1 increments. To enter the value after you input it, hit the Enter key or click anywhere on the tone. Hitting the Enter key twice will close the Tone window, so be careful. If you want to avoid "tone jumping," then you should specify 20 LPI for an image at 300 dpi or less, and 40 LPI for an image at 600 dpi or less.

- You must have something other than "none" selected in the Expression field in order to use this.

30) LPI Input button

This field is only for grayscale tones. You can specify the LPI value for applying dot shading to your selected grayscale tone at an angle of your choosing. Each click of the button steps through from 20 LPI to 27.5, 32.5, 42.5, 50, 55, 60, 65, 70, 75, to 80 LPI, displaying your image appropriately at each step. If you want to avoid "tone jumping," then you should specify 20 LPI for an image at 300 dpi or less, and 40 LPI for an image at 600 dpi or less.

- You must have something other than "none" selected in the Expression field in order to use this.

31) Angle field

This one is for grayscale tones only. You can specify the LPI value for applying dot shading to your selected grayscale tone at an angle of your choosing. You can input any value from -360 degrees to 360 degrees in increments of 0.1 degrees. We recommend that you normally use a 45-degree setting. To enter the value after you input it, hit the Enter key or click anywhere on the tone. Hitting the Enter key twice will close the Tone window, so be careful.

- You must have something other than "none" selected in the Expression field in order to use this one.

32) Angle adjustment buttons

These buttons are for grayscale tones only. By manipulating the upper and lower buttons, you can specify an angle as you like to apply dot shading. Each click of the button steps through from 0 degrees to 15, 30, 45, 60, 75, 90, 105, 120, 135, 150, and 165 degrees, displaying your image appropriately at each step. You will not be able to set this angle if you have "random" selected in the Expression field.

- You must have something other than "none" selected in the Expression field in order to use this one.

33) OK button

Hitting this button will set the tone and any modifications you have made onto your image, and return you to your graphic application. The parameters you set while using Tone will be remembered, and the next time you start it up they will be as you left them.

34) Cancel button

Hitting this button will cancel setting the tone and any modifications you have made onto your image, and return you to your graphic application. The parameters you set while using Tone will be remembered, and the next time you start it up they will be as you left them.

35) Clear Settings button

Pushing this button will reset any values you have changed to their defaults, which are as follows.
• Paste Method: Repeat, Angle: 0 degrees, Magnification: 100%, Density: 100%, Expression: Dot, LPI: 60, Angle: 45 degrees.

36) Tone Set Selection pull-down menu

This changes the tone set you wish to use. Click on this menu and select a tone set from those displayed. Then, by moving on to choose a tone set from among those in the tone set display, you can display its contents on your screen. A maximum of 20 sets within a single tone set can be displayed

- There may not be any tone set selections displayed in this field. In that case, proceed as follows:

 1. Create a new tone set by hitting the Menu button and using the "New Tone Set..." command.
 2. Import a tone set by hitting the Menu button, selecting Import Tone Set File, and saving a tone set as you wish..

37) Tone Information Display

When you select a tone from within the tone set display, a variety of information about that tone is displayed. In the Tone Information Display, from left to right, you will find the tone set index number, title, LPI, density, and size of the tone. Further, a "---" is displayed where no information is available or there is no need to display anything.

*About the tone information headings
The tone set index number is a number attached to every tone and displayed next to it in the tone set display. The numbers run from the top left tone across to the right and down, counting off each tone.

The title indicates some characteristic of a tone.

The LPI value shows how many lines of dots per inch make up a tone. For the most part, other than dot and line screens, most tones do not have this information, so nothing is displayed. Sand tones have an LPI value, but this is approximate.

Density is expressed as a percentage for each tone. A perfectly white tone has a 0% density, while a perfectly black one has 100%. A display of "100-0%" or "100-0-100%" means a given tone is a gradation.

Size is the length by width dimensions of a tone in centimeters. Tones with only a single value displayed are pattern tones with no boundary on either their width or length.

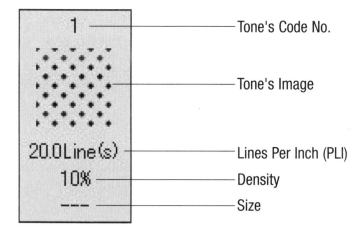

Tone's Code No.

Tone's Image

Lines Per Inch (PLI)

Density

Size

38) Menu button
Pressing this button brings up the Menu.

Supplement: Tone Set Registration and Building
If you did not check the "Also copy tone files" box at installation, the necessary tone files will not be on your local disk, meaning you cannot automatically register a tone set. The steps for manually registering and building a tone set are shown below.

❶ New Tone Set...
This command creates a new tone set on your local disk. You can use this command by selecting it from the tone set selection field, and you can create up to 1000 tone sets. When you use this command, a dialog box will appear, asking you to name your tone set. Once you've given it a name you like, click on OK to create a tone set. Click on the Cancel button to cancel the command.

❷ Rename Tone Set...
This command changes the name of the current tone set. Using it makes a dialog box appear asking you for a new tone set name. After you have entered a name you like, click on the OK button and the name will be changed. If you want to cancel the name change, hit the Cancel button.

❸ Delete Tone Set...

This command deletes the current tone set. However, the tones themselves will not be deleted and will remain on your local disk. Using this command will bring up a confirmation dialog box. If you wish to delete the tone set, click on Yes. If you do not, click on No.

❹ Import Tone Set File

This command imports a new tone set you would like to use and adds it behind the current tone set. Using this command brings up a submenu—click on View File. Another dialog box will appear to ask you where the next tone set you would like to import is located. Click on a tone set file (extension ".tst") and click on Open. If you want to cancel the import, click on Cancel. If you click on the list of previously added tone set files, you can choose a set from there as well.

- If you do not want to put the tone set you wish to import inside the tone set you are currently using, first use the Create New Tone Set command from the Menu to create a new set, and then import your desired tone set file to there.

❺ Add Tone File Folder...

Use this command to add all the tones in a folder you specify to the end of the current tone set in one stroke. Executing this command brings up a dialog box asking you for the location of the tone file folder. Choose the folder you wish and click on the OK button. If you wish to cancel the command, click on Cancel. Folders located inside the folder you specify can also be searched.

- Add Tone File...
 This command adds a single tone file to the end of the current tone set. Using this

command brings up a dialog box asking you for the location of the tone file you wish to add. Choose the ".tdt" file you wish and click on Open. If you wish to cancel the command, click on Cancel.

6 Display Name
Using this command switches between displaying all tone names and displaying all tone thumbnails.

7 Display Number
Using this command switches the display of all visible tone numbers on and off.

8 Display LPI
Using this command switches the display of all visible tone LPI values on and off.

9 Display Density
Using this command switches the display of all visible tone density values on and off.

10 Display Size
Using this command switches the display of all visible tone sizes on and off.

Tone Set Display

This command displays the contents of the selected tone set at a glance. A total of 1200 tones, 6 across and 200 down, can be displayed at once. You can execute the following actions on a single tone therein:

Click: The selected tone is applied to the Tone Draw Area.

Double Click: Same effect as hitting the OK button after the selected tone is applied.

Ctrl + Drag: Moves the selected tone as you wish.

Selecting a Tone: Displays the tone's information in the tone information display area. This area will appear blank if the display area is not open.

Right Click: Opens up an embedded smaller menu with the following commands.

Add Tone File...

This command inserts a tone directly before the selected one. Using this command brings up a dialog box asking you for the location of the tone file you wish to add. Choose the ".tdt" file you wish and click on Open. If you wish to cancel the command, click on Cancel. Using this command to add a tone will shift all the following tone files' numbers, so care must be taken when importing tone palette files and the like.

Add White Space

This command inserts or adds a blank space after the selected tone set. Clicking on a blank allows you to reset the currently applied tone.

Select All

This command selects all of the tones loaded into the tone display area.

Insert White Space

This command inserts or adds a blank space directly in front of the selected tone. Clicking on a blank allows you to reset the currently applied tone. Using this command to add a tone will shift all the following tone files' numbers, so care must therefore be taken when importing tone palette files and the like.

Remove

Using this command removes only the selected tone from the tone set. The tone itself is not deleted from your local disk.

File Info...

Using this command displays a tone's full path in a new window. Click on OK to close it.

Using Shortcut Keys

Shortcut key combinations are available for the commands listed below.

Tone Shortcuts:
Spacebar → Hand Tool
Alt → Zoom Out
Ctrl → Zoom In
Alt + Spacebar → Rotate
Ctrl + Spacebar → Scale
Alt + Ctrl → Move
Alt + Ctrl + Space → Pin

Ctrl Shift Alt Space

Error Message Overview

The various Computones error messages are listed below. Should any others occur, as they are related to your operating system and/or graphic software, please consult the appropriate manual for a solution.

Error: Insufficient memory.
Cause: The PC does not have enough memory to run Computones
Solution: Shut down any other open applications or clear the internal memory in use by another graphic application to free up system memory and reserve it. (For more details, please see your graphic software manual.) If after this you still do not have enough memory, then you must increase the amount of physical system memory. The more internal system memory you have, the smoother Computones will operate.

Error: Incorrect serial number.
Cause: The serial number has not been input correctly.
Solution: You will only be asked once for the serial number. Check the number at the end of this book, make sure you have entered it correctly, and click on the OK button.

Error: Not a tone file.
Cause: You have specified a non-tone file for import.
Solution: Select a Computones-compatible tone file (.tdt).

Error: Not a tone set file.
Cause: You have specified a non-tone set file for import.
Solution: Select a Computones-compatible tone set file (.tst).

Error: Too many items. Cannot add to the tone set.
Cause: You are trying to add over 1002 tones to a single tone set.
Solution: A single tone set can hold a maximum of 1002 tones. To set or add more tones, use Menu → Create New Tone Set...

Error:	An error has occurred.
Cause:	Something other than the above has caused an error.
Solution:	Make sure you are using a Computones-compatible environment. Reboot your computer and attempt to continue. If the same error appears, try reserving system memory. If problems still persist, then uninstall Computones and try reinstalling it. If even after that you still get the same error, then there is probably some issue with your operating system.

Error:	An "X" is displayed in place of a tone file in a tone set, as shown in figure 1.
Cause:	A tone file that is specified within the tone set cannot be found. The file itself is not present, and only the file path has been retained. If the CD-ROM drive or the local disk label has changed, or if there has been some other change in the computing environment, then this problem can occur.
Solution:	Take the following steps. Select the tone in question, and then click on the following, in order: Menu → Delete Tone Set... → Yes → Create New Tone Set... → Input new tone set name → Import Tone Set File... → Browse Files... → Choose a tone set file → Open. When the tone set is displayed as in figure 2 at the right, then the process is complete.

Question & Answer

Q How do I install Computones for Photoshop Elements 2?

A To install Computones for Adobe Photoshop Elements 2.0, follow the steps shown below.

1. Insert the Computones CD-ROM into a CD-ROM or DVD-ROM drive.

2. Double-click on the My Computer icon on the Windows desktop (Windows XP users should click on the Start Menu and then click on My Computer), and double-click on the Computones CD-ROM icon → Computones Installer.exe (or simply "Computones Installer").

3. You will be asked to which folder or directory you want to install Computones. Check the "Browse for plug-in file install location" radio button.

4. Choose a tone file install method, and click Install. A "Browse for Folder" dialog box will appear, allowing you to select the plug-in file install location. Click on the Local Disk (C:) → Program Files → Adobe → Photoshop Elements 2 → Plug-Ins. When you have selected the folder, click OK. If you have installed Photoshop Elements 2 to some other location, then select the Plug-Ins folder accordingly.

5. A "Confirm the installation directory" dialog box will appear. Check the file install location and click Yes to continue. If there is something wrong with the location, click No and repeat this process from step 3.

6. If you have checked the "Also copy tone files" box, then a "Browse for Folder" dialog box will appear. Add or remove tone files as you see fit, and click OK.

Once all installations are complete, an "Installation complete" dialog will appear. If the installation failed, repeat this process from step 2.

Q I cannot select any files to install, so I cannot install Computones!

A If during the Computones installation, the "Select installation files" dialog box has nothing displayed in the "Files to be installed" and "Files on the CD" lists, and you cannot continue with the installation, follow the steps shown below.

1. Insert the Computones CD-ROM into a CD-ROM or DVD-ROM drive.

2. Double-click on the My Computer icon on the Windows desktop (Windows XP users should click on the Start Menu and then click on My Computer), and double-click on the Computones CD-ROM icon → Computones Installer.exe (or simply "Computones Installer").

3. You will be asked to which folder or directory you want to install Computones. Check whichever radio button you like, uncheck "Also copy tone files," and click the Install button.

4. A "Confirm the installation directory" dialog box will appear. Check the file install location and click Yes to continue. If there is something wrong with the location, click No and repeat this process from step 3.

At this point the Computones plug-in and utility file installation is complete.

5. Next, install the tone files. Open up the Computones folder at its install location, create a new folder, and rename it "ToneFolder." You can verify the folder's install location in step 4 via the "Confirm the installation directory" dialog box.

6. Select the CTHDM01 folder on the Computones CD-ROM and choose one of the following methods to copy it to the Computones folder on your local disk.

 ❶ Right click on the CTHDM01 folder, and click on Copy from the pop up menu. Then right click on any blank space inside the Computones folder on your local disk and choose Paste.
 ❷ Drag the tone folders from the CD-ROM and drop them on some empty space inside Computones folder on your local disk.

7. The tone file installation is now complete. Next, start up Tones, click the Menu button, select Import Tone Set File → View File..., and import the tone file sets you just installed. If you copied tone set files that you do not need, use one of the methods below to remove them.

 ❶ If there are tones at certain resolutions you do not need, then put the entire 300 dpi or 600 dpi folders in the Recycle Bin to remove them.
 ❷ If there are certain tone genres you do not need, then open each resolution folder and place the Dot, Hatching, etc. folders in the Recycle Bin to remove them. Also remove tone set files like PT3-600-ALL.tst. that contain tones of all genres.

Q A "Cannot find the tone folder" message appears, and I cannot install Computones!

A If during the Computones installation, a "Cannot find the tone folder" message appears, and you cannot continue with the installation, follow the steps shown below.

1. Insert the Computones CD-ROM into a CD-ROM or DVD-ROM drive.

2. Double-click on the My Computer icon on the Windows desktop (Windows XP users should click on the Start Menu and then click on My Computer), and double-click on the Computones CD-ROM icon → Computones Installer.exe (or simply "Computones Installer").

Question & Answer

3. You will be asked to which folder or directory you want to install Computones. Check whichever radio button you like, uncheck "Also copy tone files," and click the Install button.

4. A "Confirm the installation directory" dialog box will appear. Check the file install location and click Yes to continue. If there is something wrong with the location, click No and repeat this process from step 3.

At this point the Computones plug-in and utility file installation is complete.

5. Next, install the tone files. Open up the Computones folder at its install location, create a new folder, and rename it "ToneFolder." You can verify the folder's install location in step 4 via the "Confirm the installation directory" dialog box.

6. Select the CTHDM01 folder on the Computones CD-ROM and choose one of the following methods to copy it to the Computones folder on your local disk.

 ❶ Right click on the CTHDM01 folder, and click on Copy from the pop up menu. Then right click on any blank space inside the Computones folder on your local disk and choose Paste.
 ❷ Drag the tone folders from the CD-ROM and drop them on some empty space inside Computones folder on your local disk.

7. The tone file installation is now complete. Next, start up Tones, click the Menu button, select Import Tone Set File → View File..., and import the tone file sets you just installed. If you copied tone set files that you do not need, use one of the methods below to remove them.

 ❶ If there are tones at certain resolutions you do not need, then put the entire 300 dpi or 600 dpi folders in the Recycle Bin to remove them.
 ❷ If there are certain tone genres you do not need, then open each resolution folder and place the Dot, Hatching, etc. folders in the Recycle Bin to remove them.

Q A "Computones may not have been installed" message appears, and I cannot install Computones!

A If during the Computones installation, a "The main Computones application may not have been installed" message appears, and you cannot continue with the installation, follow the steps shown below.

1. Insert the Computones CD-ROM into a CD-ROM or DVD-ROM drive.

2. Double-click on the My Computer icon on the Windows desktop (Windows XP users should click on the Start Menu and then click on My Computer). Next, open the Plug-In folder for

whichever application to which you want to install Computones. If you have installed these folders to their default locations, they will be located as follows. The actual plug-in folder names may vary according to software package and version.

Adobe Photoshop 5.0/5.5/6.0/7.0/CS:
C:/Program Files/Adobe/Photoshop 5.0/Plug-ins
C:/Program Files/Adobe/Photoshop 5.5/Plug-ins
C:/Program Files/Adobe/Photoshop 6.0/Plug-ins
C:/Program Files/Adobe/Photoshop 7.0/Plug-ins
C:/Program Files/Adobe/Photoshop CS/Plug-ins

Adobe Photoshop Elements 1.0/2.0:
C:/Program Files/Adobe/Photoshop Elements/Plug-ins
C:/Program Files/Adobe/Photoshop Elements 2.0/Plug-ins

Jasc Paint Shop Pro 7/8:
C:/Program Files/Jasc Software Inc/ Paint Shop Pro 7/Plugins
C:/Program Files/Jasc Software Inc/ Paint Shop Pro 8/Plugins

If you have changed the default installation directories for these applications, then the Plug-In folders will not be located as above.

3. Open up the Plug-Ins folder, create a new folder in it, and rename it "Computones." Open that folder, and create two new folders inside it. Rename one "Computones" and the other "ToneFolder."

4. Open the PlugIn folder on the Computones CD-ROM, select the screentone.8bf file, and drop it into the Computones folder on the local disk.

5. Select the Computones folder on the Computones CD-ROM, and drop it into the ToneFolder folder. The tone file installation is now complete. Next, after starting Photoshop or whichever application you are using, start up Computones → Tones or Multi Tones, click on the Menu button, select Import Tone Set File → View File..., and import the tone file sets you just installed. If you copied tone set files that you do not need, use one of the methods below to remove them.

 ❶ If there are tones at certain resolutions you do not need, then put the entire 300 dpi or 600 dpi folders in the Recycle Bin to remove them.

 ❷ If there are certain tone genres you do not need, then open each resolution folder and place the Dot, Hatching, etc. folders in the Recycle Bin to remove them.

Question & Answer

Q I tried running the uninstaller, but I cannot remove Computones!

A If you used a drag-and-drop or copy-and-paste method to install Computones from the CD-ROM, then the ComputonesUninstaller.exe (or "Computones Uninstaller") may not work. In that case, follow the steps below.

1. Double-click on the My Computer icon on the Windows desktop (Windows XP users should click on the Start Menu and then click on My Computer). Next, open the Plug-In folder for whichever application from which you want to uninstall Computones. If you have installed these folders to their default locations, they will be located as follows. The actual folder names may vary according to software package and version.

 Adobe Photoshop 5.0/5.5/6.0/7.0/CS:
 C:/Program Files/Adobe/Photoshop 5.0/Plug-ins
 C:/Program Files/Adobe/Photoshop 5.5/Plug-ins
 C:/Program Files/Adobe/Photoshop 6.0/Plug-ins
 C:/Program Files/Adobe/Photoshop 7.0/Plug-ins
 C:/Program Files/Adobe/Photoshop CS/Plug-ins

 Adobe Photoshop Elements 1.0/2.0:
 C:/Program Files/Adobe/Photoshop Elements/Plug-ins
 C:/Program Files/Adobe/Photoshop Elements 2.0/Plug-ins

 Jasc Paint Shop Pro 7/8:
 C:/Program Files/Jasc Software Inc/ Paint Shop Pro 7/Plugins
 C:/Program Files/Jasc Software Inc/ Paint Shop Pro 8/Plugins

 If you have changed the default installation directories for these applications, then the Plug-In folders will not be located as above.

2. Select the Computones folder in your application's Plug-In folder and drag-and-drop it into the Recycle Bin, or right click on the folder and select Delete from the pop up menu. To completely remove the Computones folder, open the Recycle Bin, and select Empty Recycle Bin from the File menu, or right click on the Recycle Bin and select Empty Recycle Bin from the pop up menu.

Q When I apply a duotone to my image, it looks blurry!

A When you apply a duotone to an image and then display it at 66.6%, 33.3%, or any other magnification other than 100%, it can appear blurry or appear to be "tone jumping." This is due to Photoshop's image interpolation, and there is no actual blurriness present. If you wish to confirm this via your display, be sure to set your magnification factor to 100%.

Q When I print anything out on an inkjet printer, it looks blurry!

A The way inkjet printers print things, it is not possible to print dot patterns precisely as they appear. Also, it may be that the output resolution of the printer you are using and the resolution of the tones in your image are not compatible. This can cause significant blurring or tone jumping. In order to print clearly on an inkjet printer, you must adequately adjust the resolution settings of both the printer and your image.

Q What should I do to print clearly on an inkjet printer?

A If the resolution of the printer you are using and the resolution of the tones in your image are not compatible, blurring or tone jumping can occur. The way inkjet printers print things, it is not possible to print dot patterns precisely as they appear, but by adjusting the output resolution of your printer and the resolution of your image, you can improve print quality and bring it closer to your original work.

1. Verify the output resolution of your printer in your manual.

2. Open your original image in Photoshop. Create multiple working copies of your work for printing purposes.

3. Select Image → Image Size and an Image Size dialog box will appear. Check the Resolution value in the Document Size area. If one of the following conditions applies, proceed to step 4.

 *the inkjet printer resolution = the image resolution
 *the inkjet printer resolution = an even multiple of the image resolution
 *an even multiple of the inkjet printer resolution = the image resolution

If the above conditions do not apply, then your inkjet printer will interpolate the image according to its driver, and the blurriness and tone jumping in your printed image will be worse. In this case, check the Constrain Proportion and Resample Image boxes in the Image Size dialog box, and choose Nearest Neighbor from the Resample Image pull-down menu. Set the Resolution in the Document Size area to match your printer. If your printer's resolution is 1200 dpi or higher, then enter the printer resolution divided by 2 or 4.

4. Click the OK button to apply the current resolution settings, select File → Print..., and print the image. If there is a "Bidirectional Printing" option in your Print dialog, turn it off and then print your image. Leaving this option on may cause tone jumping.

Tone Collection Guide

Dot Tones

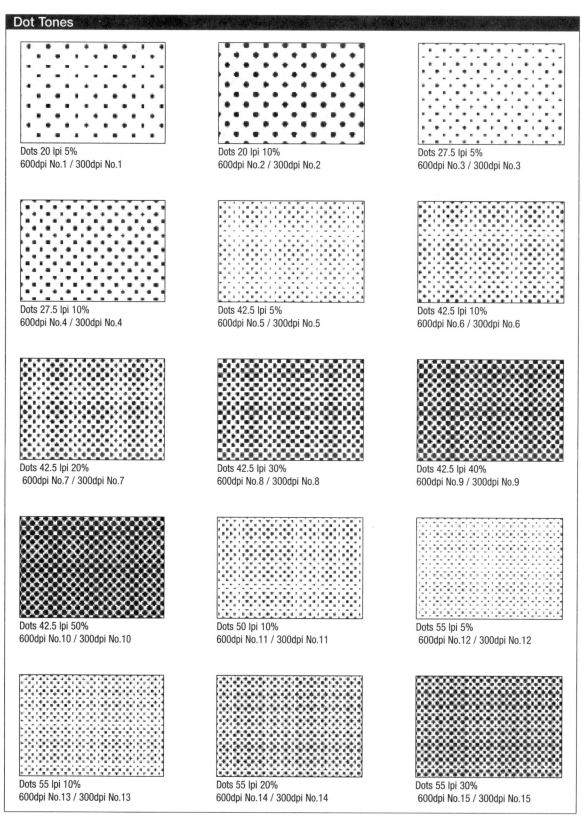

Dots 20 lpi 5%
600dpi No.1 / 300dpi No.1

Dots 20 lpi 10%
600dpi No.2 / 300dpi No.2

Dots 27.5 lpi 5%
600dpi No.3 / 300dpi No.3

Dots 27.5 lpi 10%
600dpi No.4 / 300dpi No.4

Dots 42.5 lpi 5%
600dpi No.5 / 300dpi No.5

Dots 42.5 lpi 10%
600dpi No.6 / 300dpi No.6

Dots 42.5 lpi 20%
600dpi No.7 / 300dpi No.7

Dots 42.5 lpi 30%
600dpi No.8 / 300dpi No.8

Dots 42.5 lpi 40%
600dpi No.9 / 300dpi No.9

Dots 42.5 lpi 50%
600dpi No.10 / 300dpi No.10

Dots 50 lpi 10%
600dpi No.11 / 300dpi No.11

Dots 55 lpi 5%
600dpi No.12 / 300dpi No.12

Dots 55 lpi 10%
600dpi No.13 / 300dpi No.13

Dots 55 lpi 20%
600dpi No.14 / 300dpi No.14

Dots 55 lpi 30%
600dpi No.15 / 300dpi No.15

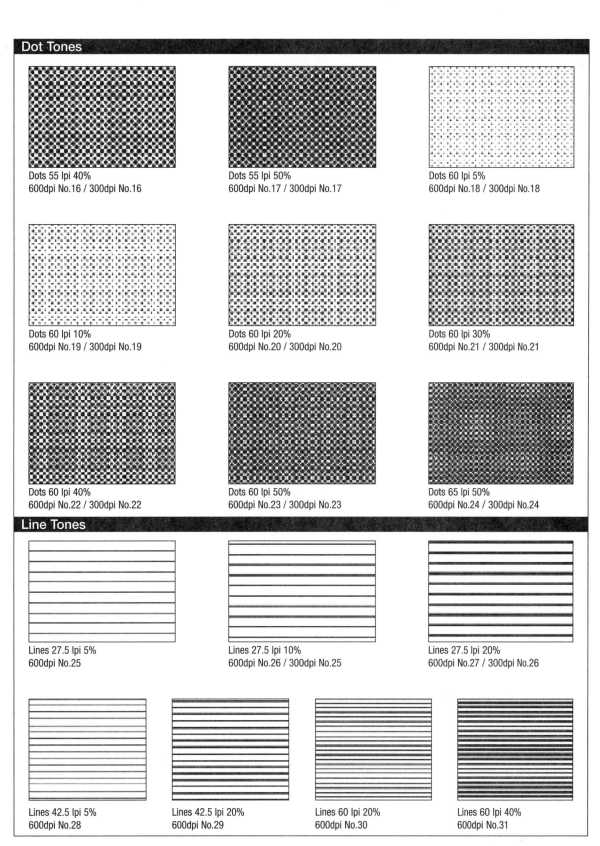

Dot Tones

Dots 55 lpi 40%
600dpi No.16 / 300dpi No.16

Dots 55 lpi 50%
600dpi No.17 / 300dpi No.17

Dots 60 lpi 5%
600dpi No.18 / 300dpi No.18

Dots 60 lpi 10%
600dpi No.19 / 300dpi No.19

Dots 60 lpi 20%
600dpi No.20 / 300dpi No.20

Dots 60 lpi 30%
600dpi No.21 / 300dpi No.21

Dots 60 lpi 40%
600dpi No.22 / 300dpi No.22

Dots 60 lpi 50%
600dpi No.23 / 300dpi No.23

Dots 65 lpi 50%
600dpi No.24 / 300dpi No.24

Line Tones

Lines 27.5 lpi 5%
600dpi No.25

Lines 27.5 lpi 10%
600dpi No.26 / 300dpi No.25

Lines 27.5 lpi 20%
600dpi No.27 / 300dpi No.26

Lines 42.5 lpi 5%
600dpi No.28

Lines 42.5 lpi 20%
600dpi No.29

Lines 60 lpi 20%
600dpi No.30

Lines 60 lpi 40%
600dpi No.31

Tone Collection Guide

San Tones

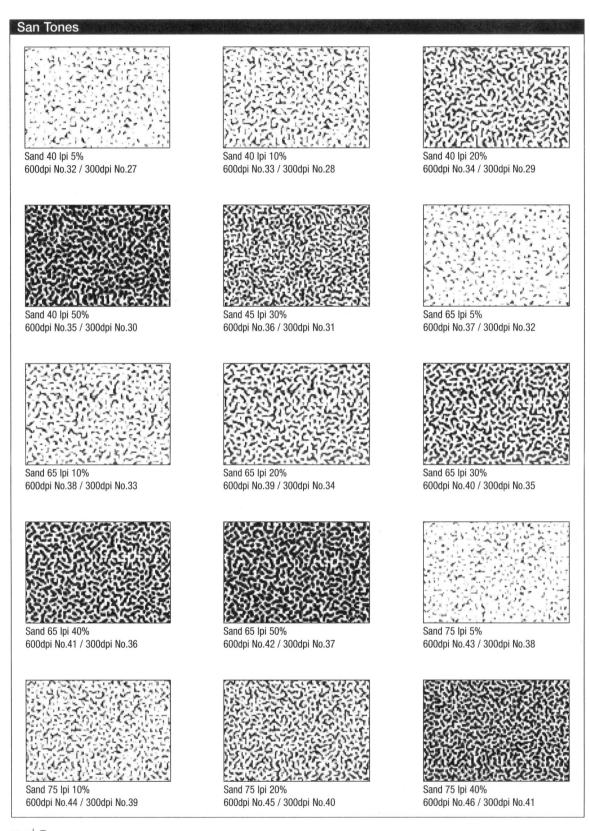

Sand 40 lpi 5%
600dpi No.32 / 300dpi No.27

Sand 40 lpi 10%
600dpi No.33 / 300dpi No.28

Sand 40 lpi 20%
600dpi No.34 / 300dpi No.29

Sand 40 lpi 50%
600dpi No.35 / 300dpi No.30

Sand 45 lpi 30%
600dpi No.36 / 300dpi No.31

Sand 65 lpi 5%
600dpi No.37 / 300dpi No.32

Sand 65 lpi 10%
600dpi No.38 / 300dpi No.33

Sand 65 lpi 20%
600dpi No.39 / 300dpi No.34

Sand 65 lpi 30%
600dpi No.40 / 300dpi No.35

Sand 65 lpi 40%
600dpi No.41 / 300dpi No.36

Sand 65 lpi 50%
600dpi No.42 / 300dpi No.37

Sand 75 lpi 5%
600dpi No.43 / 300dpi No.38

Sand 75 lpi 10%
600dpi No.44 / 300dpi No.39

Sand 75 lpi 20%
600dpi No.45 / 300dpi No.40

Sand 75 lpi 40%
600dpi No.46 / 300dpi No.41

Sand Tones

Sand Grain 5%
600dpi No.47 / 300dpi No.42

Sand Grain 10%
600dpi No.48 / 300dpi No.43

etc

Hatching
600dpi No.49 / 300dpi No.44

Samekomon
600dpi No.50 / 300dpi No.45

Dots Marble 01
600dpi No.51 / 300dpi No.46

Sand Hatching HS02
600dpi No.52 / 300dpi No.47

Sand Hatching Mist
600dpi No.53 / 300dpi No.48

Flash Effect Lines 01
600dpi No.54 / 300dpi No.49

Speed Lines 02
600dpi No.55 / 300dpi No.50

Rose Pattern Lace
GRAY No.1

Floral Lace 01
GRAY No.2

Floral Lace 02
GRAY No.3

Floral Lace 03
GRAY No.4

Leaf Pattern Lace
GRAY No.5

Tone Collection Guide

Gradation

Dots Gradation / 40 lpi / 100% - 0% - 100% / 4.4cm
600dpi No.56 / 300dpi No.51

Dots Gradation / 40 lpi / 100% - 0% - 100% / 6.6cm
600dpi No.57 / 300dpi No.52

Dots Gradation / 40 lpi / 100% - 0% - 100% / 16.5cm
600dpi No.58 / 300dpi No.53

Dots Gradation / 40 lpi / 100% - 0% - 100% / 33.0cm
600dpi No.59 / 300dpi No.54

Dots Gradation / 60 lpi / 100% - 0% - 100% / 1.0cm
600dpi No.60 / 300dpi No.55

Dots Gradation / 60 lpi / 100% - 0% - 100% / 2.0cm
600dpi No.61 / 300dpi No.56

Dots Gradation / 60 lpi / 100% - 0% - 100% / 4.4cm
600dpi No.62 / 300dpi No.57

Dots Gradation / 60 lpi / 100% - 0% - 100% / 6.6cm
600dpi No.63 / 300dpi No.58

Dots Gradation / 60 lpi / 100% - 0% - 100% / 11.0cm
600dpi No.64 / 300dpi No.59

Dots Gradation / 60 lpi / 100% - 0% - 100% / 16.5cm
600dpi No.65 / 300dpi No.60

Dots Gradation / 60 lpi / 100% - 0% - 100% / 22cm
600dpi No.66 / 300dpi No.61

Dots Gradation / 60 lpi / 100% - 0% - 100% / 33cm
600dpi No.67 / 300dpi No.62

Dots Gradation / 65 lpi / 100% - 0% - 100% / 1.0cm
600dpi No.68 / 300dpi No.63

Dots Gradation / 65 lpi / 100% - 0% - 100% / 2.0cm
600dpi No.69 / 300dpi No.64

Dots Gradation / 65 lpi / 100% - 0% - 100% / 4.4cm
600dpi No.70 / 300dpi No.65

Dots Gradation / 65 lpi / 100% - 0% - 100% / 6.6cm
600dpi No.71 / 300dpi No.66

Dots Gradation / 65 lpi / 100% - 0% - 100% / 11.0cm
600dpi No.72 / 300dpi No.67

Dots Gradation / 65 lpi / 100% - 0% - 100% / 16.5cm
600dpi No.73 / 300dpi No.68

Dots Gradation / 65 lpi / 100% - 0% - 100% / 22cm
600dpi No.74 / 300dpi No.69

Dots Gradation / 65 lpi / 100% - 0% - 100% / 33cm
600dpi No.75 / 300dpi No.70

Dither Gradation

Dither Gradation 100% - 0% / 33 x 22cm
600dpi No.76 / 300dpi No.71

Dither Gradation 100% - 0% / 33 x 33cm
600dpi No.77 / 300dpi No.72

Sand Gradation / 40 lpi / 100% - 0% - 100% / 33 x 22cm
600dpi No.78 / 300dpi No.73

Flower

Cosmos Pattern
600dpi No.79 / 300dpi No.74

Cherry Blossom 02
600dpi No.80 / 300dpi No.75

Rose Pattern 01
600dpi No.81 / 300dpi No.76

Floral Pattern A
600dpi No.82 / 300dpi No.77

Bouquet (2 types)
600dpi No.83 / 300dpi No.78

Dither Mrgrt 01
600dpi No.84 / 300dpi No.79

Sand Hatching Fl02
600dpi No.85 / 300dpi No.80

Rose 03
600dpi No.86 / 300dpi No.81 GRAY No.6

Sunflower
600dpi No.87 / 300dpi No.82GRAY No.7

Anemone
GRAY No.8

Rose 02
GRAY No.9

Floral Pattern
GRAY No.10

Floral Pattern 04
GRAY No.11

Effect

Real Lightning
600dpi No.88 / 300dpi No.83

Roll Lighting Msk
600dpi No.89 / 300dpi No.84

Lightning 02
GRAY No.12

Deluge
GRAY No.13

Parallel Beams
GRAY No.14

Sand Hatching Gradation
600dpi No.90 / 300dpi No.85

Sand Hatching EG05
600dpi No.91 / 300dpi No.86

Sand Hatching SG
600dpi No.92 / 300dpi No.87

Clouds

Clouds 06
GRAY No.15

Clouds 08
GRAY No.16

Clouds 46
GRAY No.17

Clouds 50
GRAY No.18

Tone Collection Guide

Checker 01
600dpi No.93 / 300dpi No.8 GRAY No.19

Checker 02
600dpi No.94 / 300dpi No.89 GRAY No.20

Checker 03
600dpi No.95 / 300dpi No.90 GRAY No.21

Checker 04
600dpi No.96 / 300dpi No.91 GRAY No.22

Checker 06
600dpi No.97 / 300dpi No.92 GRAY No.23

Checker 07
600dpi No.98 / 300dpi No.93 GRAY No.24

Checker 08
600dpi No.99 / 300dpi No.94 GRAY No.25

Checker 09
600dpi No.100 / 300dpi No.95 GRAY No.26

Checker 11
600dpi No.101 / 300dpi No.96 GRAY No.27

Rubber Weave
600dpi No.102 / 300dpi No.97

Coarse Hatching
600dpi No.103 / 300dpi No.98 GRAY No.28

Wicker 01
600dpi No.104 / 300dpi No.99 GRAY No.29

Wicker 02
600dpi No.105 / 300dpi No.100 GRAY No.30

Flower 02B
600dpi No.106 / 300dpi No.101

Checker 13
GRAY No.31

Checker 14
GRAY No.32

Alan 02
GRAY No.33

Hairline
GRAY No.34

Cotton Lining
GRAY No.35

Plain Fabric 02E
GRAY No.36

Lines 02
GRAY No.37

Wave
GRAY No.38

Quilted Heart
GRAY No.39

Leopard
GRAY No.40

Rose Gray 02
GRAY No.41

Hibiscus 02
GRAY No.42

Flower 01
GRAY No.43

Flower 02A
GRAY No.44

Wavy Lines 03 10%
600dpi No.107 / 300dpi No.102

Seaweed 02
600dpi No.108 / 300dpi No.103

Hatching Dbl Cross
600dpi No.109 / 300dpi No.104